A Sense of Belonging to Scotland: Further Journeys

To Stuart and Fiona

Good luck in your new home!

Best wishes

from Andy Hall

First published in 2005 by
Mercat Press Ltd, 10 Coates Crescent, Edinburgh EH3 7AL

ISBN 1841830895

For Sylvia, Stuart and Lynsey,
who have indulged me by allowing me to fulfil my dream

All text © Andy Hall and the contributors
All photographs © Andy Hall, except:

Gerry Rafferty, p. 4 (Gerry Rafferty); Dougray Scott, p. 6 (Sarah Dunn/K2); Colin Montgomerie, p. 8 (Mark Newcombe, Visions in Golf); Emma Thompson, p. 10 (Andy Gotts; www.andygotts.com); Ricky Ross, p. 12 (Pat Pope Photography); Alexander McCall Smith, p. 16 (Sunday Post); Marti Pellow, p. 18 (James Bareham Photography); Siobhan Redmond, p. 20 (Robert McBain's family); Denis Law, p. 22 (Sunday Post); Ken Bruce, p. 24 (BBC Picture Library); Dawn Steele, p. 26 (Jaap Buitendijk); Alastair Mackenzie, p. 28 (BBC Picture Library); Colin Prior, p. 30 (Colin Prior); Sarah Heaney, p. 32 (Upfront Photography); Jimmy Johnstone, p. 34 (Sunday Post); Karen Matheson, p. 36 (Paul Rider Photography, www.shootgroup.com); Dame Elizabeth Blackadder, p. 40 (Dame Elizabeth Blackadder); Alan Hansen, p. 42 (BBC Picture Library); Phil Cunningham, p. 44 (Robin Gillanders); Calum Macdonald, p. 46 (Calum Macdonald); Tom Hunter, p. 48 (Atom Photography); Dr. Winnie Ewing, p. 50 (Empics/PA); Calum Kennedy, p. 54 (Daily Record); Kenny Logan, p. 58 (Gordon Fraser, Scottish Rugby Union); John Lowrie Morrison, p. 60 (George Birrell); Jackie Bird, p. 64 (Jackie Bird); Alan Sharp, p. 70 (Nick Wall, Camera Press, London); Sir Ian Wood, p. 72 (Sir Ian Wood); Willie Miller, p. 74 (Aberdeen Football Club); Dr Tom Sutherland, p. 76 (Sutherland Foundation); Kevin McKidd, p. 78 (Empics/PA); Kenneth McKellar, p. 82 (Lismore Recordings); Steve Forbes, p. 86 (Steve Forbes); Angus Roxburgh, p. 92 (Angus Roxburgh); Lorraine McIntosh, p. 94 (Lorraine McIntosh); Fiona Kennedy, p. 98 (Clive Arrowsmith Photography); Michelle Mone, p. 102 (MJM International); Sir Chay Blyth, p. 104 (On Edition Photography); John Bellany, p. 108 (John Bellany); Gavin Esler, p. 110 (BBC Picture Library)

Printed in China through World Print Ltd

A Sense of Belonging to Scotland:
Further Journeys

The favourite places of Scottish personalities

ANDY HALL

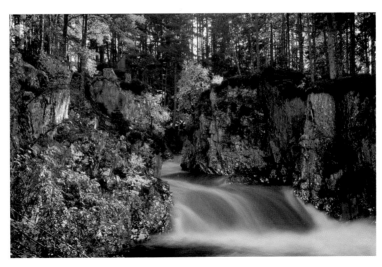

Pattack Falls, Badenoch (Chosen by Phil Cunningham)

mercatpress
www.mercatpress.com

Acknowledgements

In the course of producing *A Sense of Belonging to Scotland* I've received much help from a variety of sources too numerous to mention but, in particular, my grateful thanks go to all of the participants in the book. They are all very busy people but, without exception, they have embraced the idea with enthusiasm and commitment. Anyone who reads the texts, all different in style and content, will find them to be fascinating insights into some of Scotland's best-loved personalities.

I owe a huge debt of gratitude to Visit Scotland, particularly Philip Riddle and Karin Finlay, for recognising the uniqueness of this piece of work and giving me support and encouragement at critical times in its realisation.

I would like to thank Raeburn Christie, Clark and Wallace (solicitors) of Aberdeen and my good friend Keith Allan for their continued faith in my photography, which they have expressed in the form of financial support since my adventures into publishing began.

On the production side of the project, I'd like to thank my friends at Mercat Press, particularly Seán Costello, for putting together such a lovely publication, and Niall and Jacqueline Irvine of Perspectives in Ellon for the exceptional scans and pre-production material that I needed, usually at the eleventh hour.

I'd like to acknowledge the friendship and advice of Alison McRae of Blue Toucan, who has shown great belief in the project, and has been a constant source of ideas, encouragement and inspiration to me. I'm delighted to have been the beneficiary of such a talented and creative mind. For his assistance in researching locations, and his eye for detail, I'd like to thank my friend Alan Elkington of Drumlithie.

My thanks go to the Royal and Ancient Golf Club of St Andrews, Cruden Bay Golf Club, Loch Lomond Golf Club, Gleneagles Hotel, Braid Hills Golf Club and Silverknowes Golf Club for permission to take photographs from their courses. Also Rangers Football Club for permission to include Ibrox; Historic Scotland and the National Trust for Scotland for permission to photograph Edinburgh Castle, Callanish in Lewis, Bothwell Castle, and Culzean Castle; and to Ardverikie Estate in Loch Laggan for giving me access to take Dawn Steele's photograph; and finally to Stirling Council for the Wallace Monument.

I am very grateful to my friends who have driven me to some of Scotland's most inaccessible places and helped me carry equipment to the back of beyond. These include Rick Swan, Neil Murray, Brian Duncan, Jim Johnstone, Robert Buckley, Jim Glennie and Steve Duncan.

I would also like to acknowledge the contribution of members of my family who have put me up with little or no warning, particularly my sister Iona, cousins Kathleen, Christine, Margaret, the two Catrionas and my Aunt Cathy on the beautiful Isle of Mull.

Similarly, to Ewan McGregor for valuing and unhesitatingly endorsing the quality of my photography and to Carol and Jim McGregor who have facilitated communications with Ewan since the first letter six years ago. Your friendship, enthusiasm and involvement have meant a great deal to me and inspired me to achieve something that we can all be proud of.

I'd like specifically to acknowledge the contribution of my dear friend, Dougie 'Map Man' Abernethy. Dougie's encyclopaedic knowledge of Scotland's west coast, understanding of light and weather conditions and shared love of the country has helped shape both volumes of *A Sense of Belonging to Scotland*. A family friend's little boy, Angus MacDonald from Harris, once advised me to 'have a word with my Uncle Dougie, he controls the weather.' There have been many times when I have fully believed Angus's perceptive observation.

My final love and thanks go to my wife, Sylvia, for her continued support and artistic insight.

★

A Photographic Note

All of the photographs were taken using a Canon EOS 3, an exceptional camera.

The film is exclusively Fuji Velvia 50 ASA, soon to be replaced by Fuji Velvia 100. Velvia is extremely sympathetic to the atmospheric photographs that I like to take.

None of the shots were handheld; a tripod was used to ensure front-to-back sharpness.

Contents

Foreword ★ vi

Map of Scotland ★ 1

Foreword

A Sense of Belonging to Scotland: Further Journeys is the second half of a project I conceived of in the year of the millennium. The first part of the collection was published in Edinburgh in October, 2002. The task I set myself was to photograph the favourite places of some of Scotland's best-loved personalities from many different walks of life and to encourage them to write a descriptive piece on why the place is so meaningful to them. The criterion for selection was a subjective one, in that I admired the people's achievements either personally or professionally.

The resulting images have taken on a significance far beyond that which I originally envisaged. My role was to use all the photographic skill available to me to encapsulate the essence of the place in as atmospheric a way as possible. This often meant multiple journeys of hundreds of miles to capture the perfect light that sometimes only appeared for a moment. Beyond this, my control was relinquished as I handed over the responsibility of describing the places to the participants.

I find it difficult to convey how gratified I am that, for each contributor, my photograph has unlocked a casket of very personal memories which they have taken great care to describe both revealingly and sensitively.

The places mean different things to different people. For some it is a memory from childhood, or a place to return to in order to re-establish a sense of identity. For others it is simply a view that continues to take their breath away.

I feel very proud to have earned the approval of so many people who have placed their trust in me by revealing insights into themselves that were previously undocumented. Perhaps my proudest moment was when I unexpectedly received a letter from Jack McConnell, Scotland's First Minister, to inform me that volume one of *A Sense of Belonging to Scotland* had been used on his ministerial visit to China in 2004.

Further Journeys is a continuation of the theme of the first volume. It conveys the beauty and diversity of Scotland and what it means to Scots, both native and adopted. When seen as a complete collection it offers a unique insight into the character of Scotland's wonderful landscape and the achievement of its people. My own motivation has been my love of Scotland, its people, its landscape and its light. The feeling of elation when all the elements of an atmospheric photograph come together in perfect harmony is indescribable.

In his descriptive piece in volume 1, Ewan McGregor said that the photographs would evoke a 'beautiful melancholia' for Scots all over the world who are away from home. The joy *of A Sense of Belonging to Scotland* is that it encourages everyone to visit their own special place, even if it is only in their imagination.

I hope you enjoy the journeys.

Andy Hall,
October 2005

100 kilometres

Callanish Stones, Isle of Lewis

West Coast of the Isle of Harris
East Coast of the Isle of Harris
Clachan Sands, North Uist
Gairloch
Lossiemouth
New Deer Parish Church
Cruden Bay Golf Course
Aberdeen
Arisaig
Ardverikie
Pattack Falls
Drumochter
St Cyrus
Lunan Bay
Gribun, Mull
Loch Etive
Loch Tummel
The Berry Fields of Blairgowrie
The River Tay
Traigh Ban, Iona
Port Grullain Bay, Iona
The Old Course, St Andrews
The King's Course, Gleneagles
Lochgoilhead
Loch Lomond Golf Club
The Wallace Monument
Airth
Gullane
Fintry
Silverknowes
Loch Eck
Bowling Basin
Golf Course
Arthur's Seat
Greenock
Braid Hills
Eyemouth
Saligo Bay, Islay
Kyles of Bute
Glasgow
Greyfriars
Kilbride Bay
Monastery
Portnahaven, Islay
Ettrick Bay
Bothwell
Castle
Hyndford Bridge, Lanark
Gigha and Jura
Arran
Barassie
Hawick
Dunure Castle
Glen Afton
Culzean Castle

Saligo Bay, Isle of Islay

The favourite place of Lord George Robertson of Port Ellen

The island of Islay is unique. Its trademark whiskies, nature, scenery, and rich history make it stand out among Scotland's greatest national places.

But among its greatest strengths is its light. There is a distinctive purity and clearness of light, in all Islay's varied weathers, which I have seen in very few places in the world. This is especially so at Saligo Bay on Islay's north-west coast. This photograph captures a hint of what that brilliant, illuminating light does.

As a child, born on the island, we were regularly attracted to the magic of Saligo, and every trip produced excitement. Amid the rocks, the endlessly reshaped expanse of sand, the water in pools and the might of the ocean, we had the playground of dreams.

Then it became the favourite day out of our own children well into adolescence, and now a new generation knows the buzz.

A child, however perceptive, will not notice the light or recognise the fine and delicate beauty it imparts to a magnificent photograph such as this. But they know the place is special and different, and eventually they recognise that light and life are intimately connected, and therein is one of the secrets of the enduring vitality of Saligo Bay.

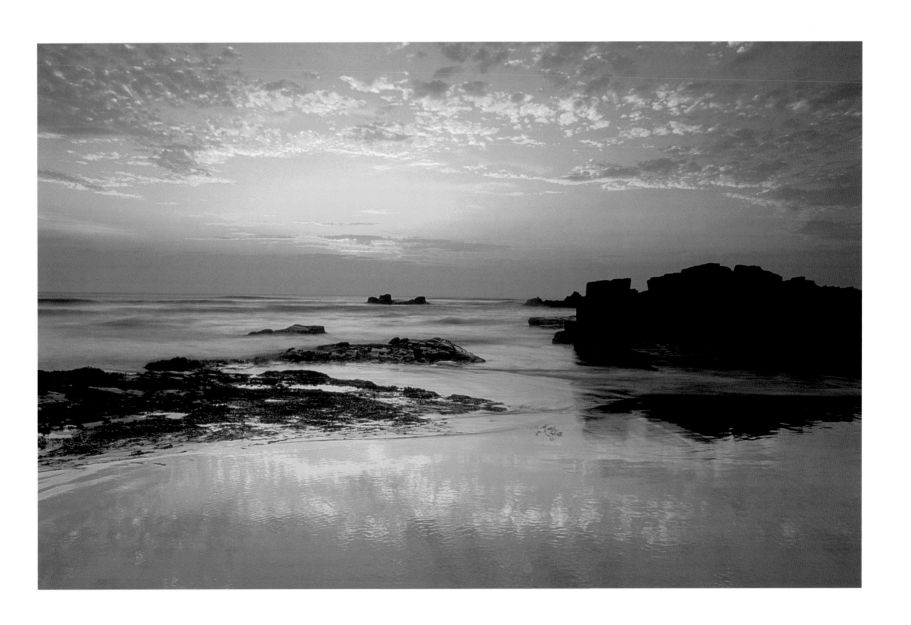

Arisaig, Lochaber
The favourite place of Gerry Rafferty

I first visited this part of Scotland with my mother, father and brothers when I was seven years of age. For the few days we were there, we were lucky because the weather was hot and sunny, which made the whole experience even more beautiful.

Andy has captured the wonderful quality of light which can be experienced in that part of the west coast of Scotland.

This particular view of Rum and Eigg from the mainland evokes so many magical childhood memories for me. And I am so pleased to have such a beautiful photograph of somewhere that is very dear to me.

So thank you, Andy. A wonderful piece of work and thanks for asking me to contribute. It was an honour.

Gerry Rafferty.

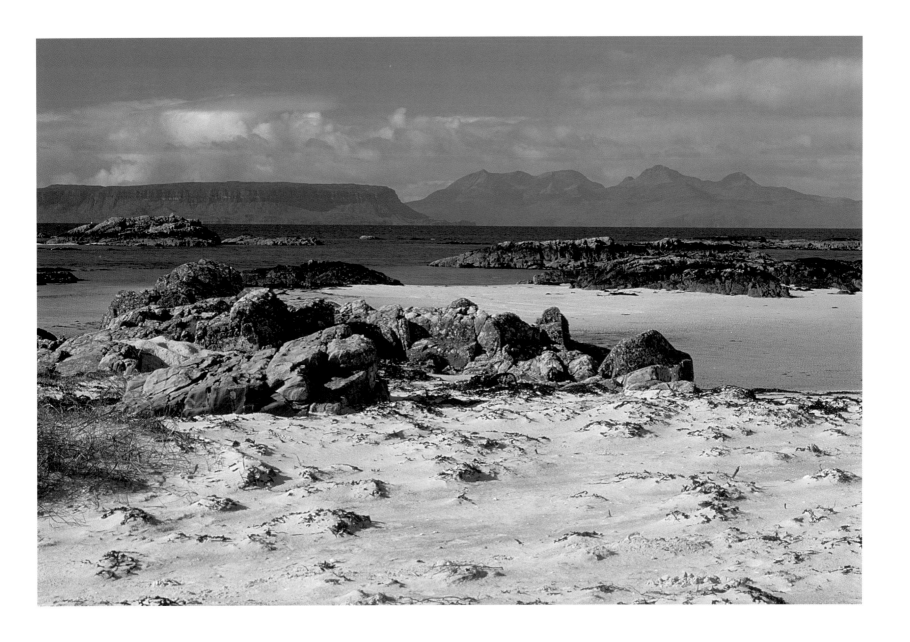

Gigha and Jura, Argyllshire
The favourite place of Dougray Scott

This photograph of Gigha and Jura conjures up so many special memories for me, from an early age. I used to visit Gigha with my family over a period of many years and whenever I come here, I always feel incredibly happy and alive.

I remember the clear turquoise waters and beautiful gardens on the isle. I remember the journey to get here from Glasgow, past Loch Fyne and down the Kintyre peninsula. It is my favourite journey in the world.

When I stand here looking at this most extraordinary sunset, I feel so fortunate to be Scottish. Whenever anyone asks me where they should visit in Scotland, I always send them here. It also reminds me of journeys with my father.

Dougray Scott

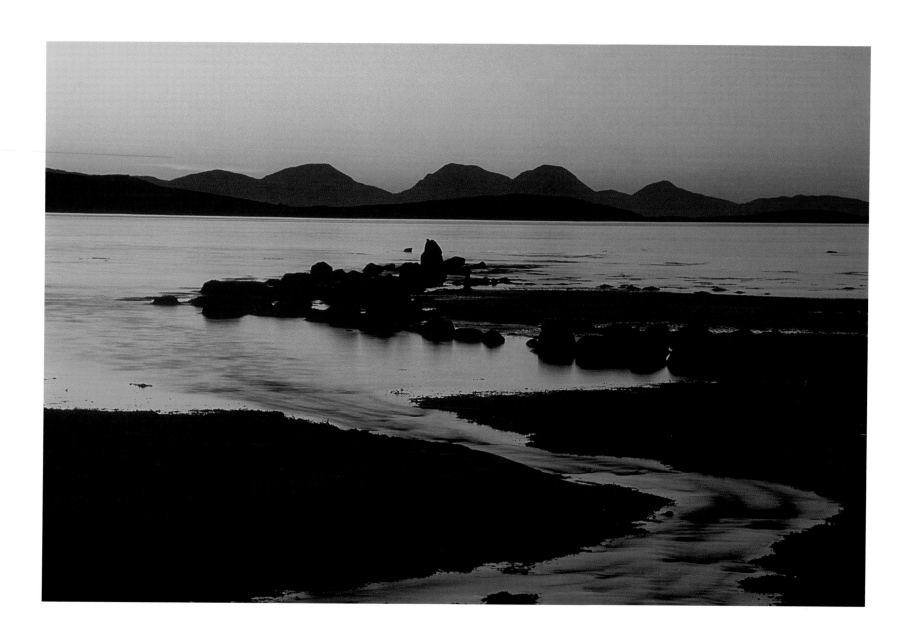

Culzean Castle, Ayrshire
The favourite place of Colin Montgomerie

I spent my early childhood years growing up in Troon in Ayrshire on the west coast of Scotland. I returned to live there a few years later when my family moved back to the town and Troon was where I began the first steps of my career as a professional golfer.

This part of Scotland and the surrounding area have great memories for me and I feel immensely proud to have such close ties to this particular region.

Culzean Castle, a fine Georgian masterpiece by Robert Adam, characterises this region of Scotland for me and reminds me so much of where I spent my youth. The Castle stands high on a cliff midway between Troon and Turnberry Golf Clubs which, to me, are two of the finest links courses in Scotland and places where I played so much of my amateur golf, sometimes competitively and many times simply for pure pleasure.

The views from Culzean Castle are tremendous and from the Castle grounds it is possible to look out towards the mountains on the Isle of Arran. Andy's photograph captures the dramatic look of Culzean Castle superbly and this is exactly how it would look in the morning light. With such a pure blue sky the views to the Isle of Arran on such a day would have been fantastic. It truly is a magnificent example of a Scottish treasure.

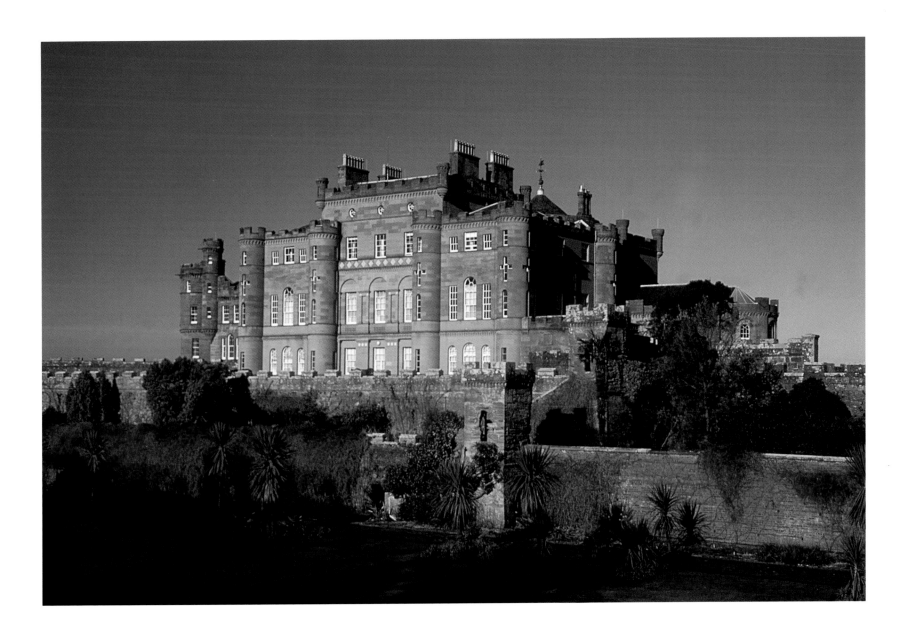

Loch Eck, Cowal

The favourite place of Emma Thompson

I saw Loch Eck for the first time when I was three months old. Since then, I've played on its banks, picnicked on its beaches, swum in its chilly, unsalted depths, cycled round it, drunk it, got drunk near it, kissed in boats on it, seen it change from blue to green to wizened old grey to frozen and stiller than death, made a film by it, got married near it and never wearied of it.

It is, in short, part of my DNA and I cannot do without it.

Emma Thompson

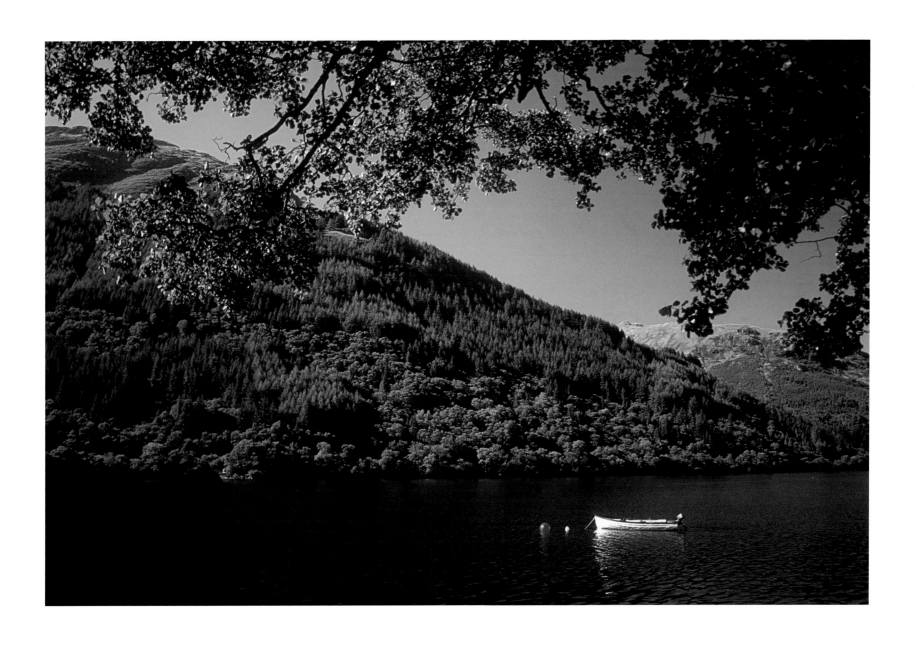

Lunan Bay, Angus
The favourite place of Ricky Ross

I can't remember the first time I went to Lunan Bay but I do recall being there at many points in my life.

My friends in Primary 7 said I should join the Crusaders, as they were going camping there under canvas. It was this camp I remember best. We ate out in the open air, combed the beach, then straddled the nets to catch the wild salmon, and played a 'wide game'. The last event seemed to me to be the best organised fun I'd ever had.

All the time we drifted between the campsite, the sand dunes and the beach. I returned home having had one of the best weekends of my life. My mum enquired whether the recent downpours hadn't cast a slight shadow over the proceedings. I told her that the rain had been negligible as she emptied out my rucksack to find every item soaking wet.

I've been back since a few times. Sometimes with groups, but lastly with my own children. We jumped the same sand dunes and rejoiced in having this most beautiful place all to ourselves.

Andy's photograph does what all good photographs should do—catch the subject off guard. In the dead of winter, snow-covered, more beautiful than anyone could possibly expect, with only a few lonely footsteps to betray a solitary visitor.

People talk endlessly of Scotland's west coast—rightly so—but this stunning image shows the serene, low beauty of the east.

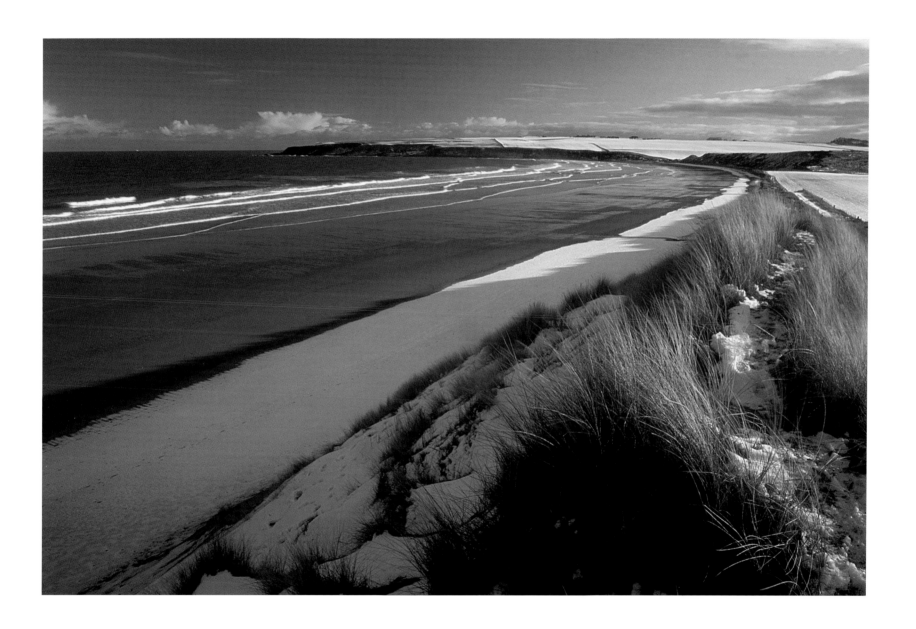

The Berry Fields of Blairgowrie, Perthshire

The favourite place of Stuart Cosgrove

So many of my early memories were forged on the berry fields of Perthshire. I was a member of the Letham Squad, a busload of pickers that would be taken from my housing scheme in the northern edges of Perth to the Essendy fields near Blairgowrie.

The Berries were a wonderland of words like luggie and dreel that had survived almost unchanged from Old Scots. You picked raspberries into a luggie which, by my time, was a plastic bucket, and to pick strawberries you were allocated a dreel, a row of berries that stretched up through the field. The object was to pick it clean, fill punnets to the brim, and then carry them to the weighing station where you were paid.

The Berries were a peasant experience turned working-class. Those that went were often from the poorest families in Perth and it was often very rowdy and hectic. The highlight was a piece break where you could gorge on rolls and Vimto. It was a very maternal environment, dominated by women and children.

Some of the most powerful images I have of self-confident femininity were forged at the Berries. The woman who hired the bus and led our squad was Mrs Soutar, mother of the famous Stagecoach millionaire, Brian Soutar. This was one of their first ventures into transport. When there was a dispute over wages, it was Mrs Speirs and Mrs Watt who led the delegation up to the Big Hoose to ask for another penny a pound.

As a kid with eczema, I probably should have been kept away from the Berries, and remember nights clawing away at my wrists. They were always red-raw with allergies. But when the bus arrived at night to take you home and you 'made' two quid, it was a great feeling of triumph over adversity. Sometimes we managed to steal a few punnets—hidden in the sleeves of an anorak—and then sell them outside Charlie's chippy back on the scheme.

The pickers are now drawn from Eastern Europe, especially the Czech Republic, and casting back further to the pre-war era, it was Irish labourers who came to pick Essendy clean.

What I most like about the Berries is the way it captures Scotland's changing social anthropology. I can't eat a strawberry now without memories flooding through my mind. It is a real sense of belonging, of being from a community that I still massively respect.

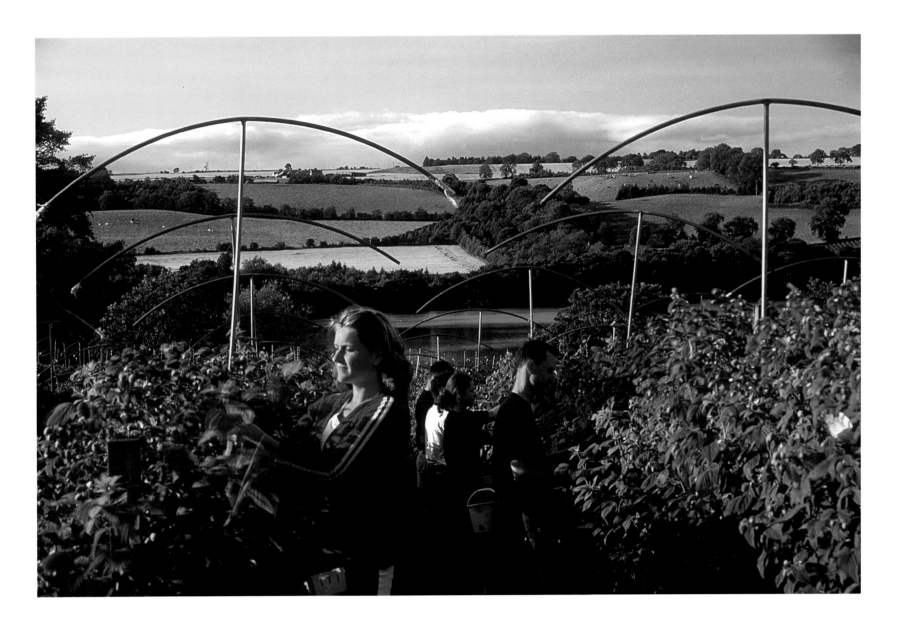

East Lothian from Gullane

The favourite place of Alexander McCall Smith

There are some places where clouds and light combine in a particularly pleasing way. Whenever I leave Gullane in East Lothian, heading back to Edinburgh, the sky seems to put on a marvellous display, and for a moment I am transported back, magically, to a time of my youth, when such light seemed all about me.

This is a landscape that makes me shiver.

Alexander McCall Smith

Bowling Basin, Dunbartonshire
The favourite place of Marti Pellow

As a child I would often visit Bowling Harbour with my father to watch the ships go up and down the Clyde. Looking at the names of the ships and where they came from, like Chile or Argentina, always made my imagination run wild, as if this little spot was the gateway to the rest of the world.

My father used to go there as a child to watch the men offload their cargo, and when it was potatoes he would pick up the loose ones, build a fire and cook them by the side of the Clyde. This image always brings a smile to my face, and today as a man, whenever I have some time, I like to visit Bowling Harbour and just think of family and loved ones. It always seems to give me a great sense of peace, especially when it is raining and windy.

I feel that this photograph captures Bowling Harbour perfectly. For me it's quite a sad picture: the Clyde is no longer famous for its shipbuilding and the skeleton ships represent this for me. There is also a great sense of serenity to the photograph.

Thank you, Andy.

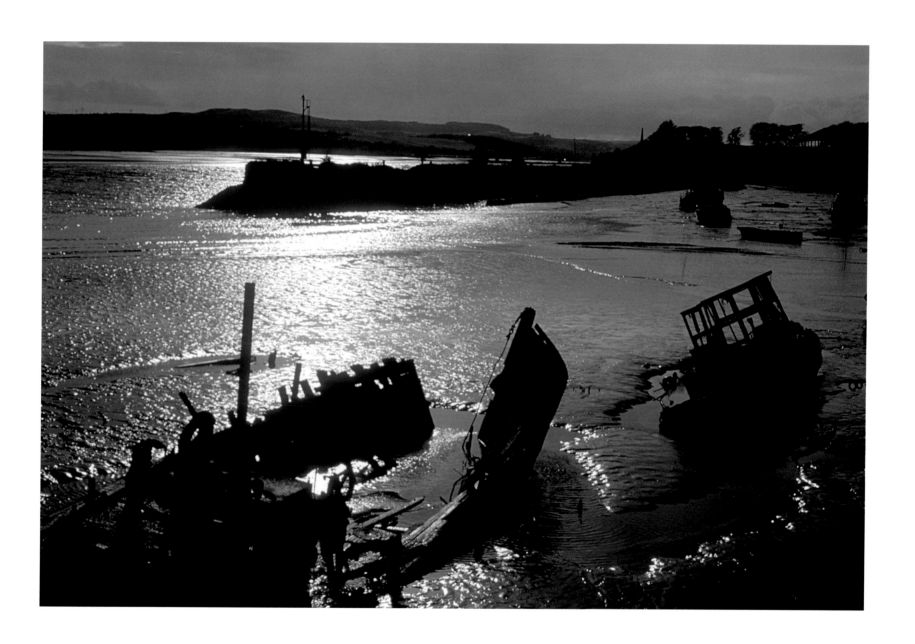

Bothwell Castle, Lanarkshire
The favourite place of Siobhan Redmond

Throughout my childhood and well into my adolescence, the Redmonds went on jaunts to Bothwell Castle. We held no truck with cars (or fashionable footwear), so the four of us, Mum, Dad, my sister Grainne and I would get the red bus to Uddingston and walk out from there.

Even getting the red bus made us feel quite holidayish—we spent large amounts of our city-bound lives on Corporation transport so a Lanarkshire bus was an almost exotic novelty.

The favourite time to go was early in the year when the snowdrops come out; later there'd be breathtaking displays of bluebells, but I always loved the tottie and tenacious snowdrops cocking a snook at winter.

What Andy's photograph captures so beautifully is the fairytale moment when this fun-size castle lies just before you—I love the domestic feel of the building and the approach through the wee winding wood.

I was an utter romantic (and a perfect pest) as a child, only occasionally emerging from my private pretend life as a princess. I distinctly remember singing 'Mary Queen Of Scots' Lament' from up in the tower and thrilling at the thought of her there in her love-struck days, all desperate and doomed. Oh, the glamour of it...

And on the way home there'd be Tunnock's tearooms with Jackie, their mynah bird, starring throughout as waitress: 'Pie and chips for two, Margaret!'; customer: 'Rangers for the cup!'; and advertisement: 'Tunnock's Caramel Wafers!' Then the exciting red bus back to Tollcross and the rare sensation for my bookish family of having had a day in the actual outdoors.

I'm so delighted to have this picture from my own long ago realised for me by Andy—it rushes me down the years to a time of treats and togetherness and the infinite promise of springs still to come.

Siobhán Redmond

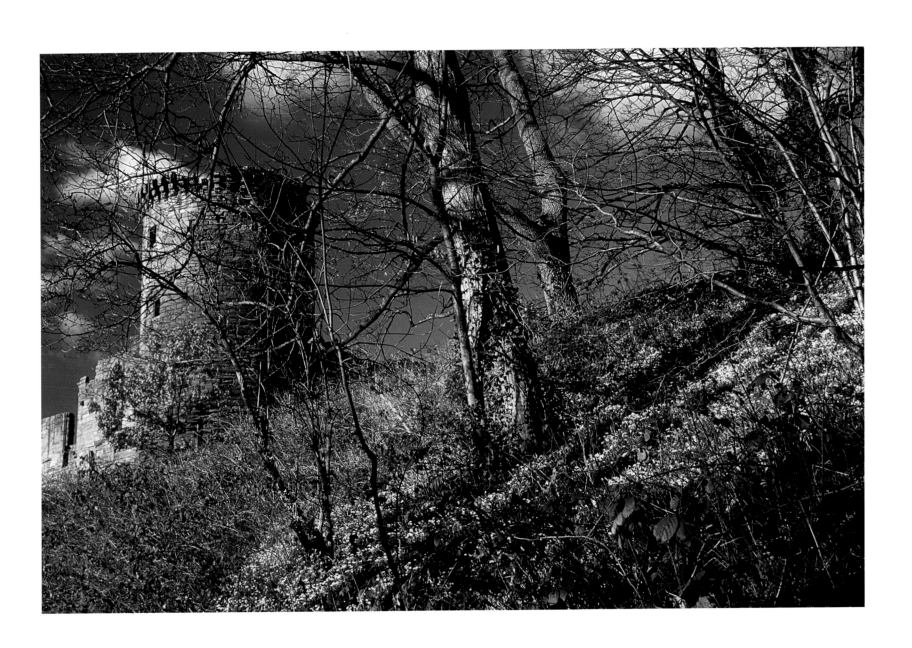

Aberdeen Harbour

The favourite place of Denis Law

I left Aberdeen when I was 15 to join Huddersfield FC. It was the first step on a career that would take me all over the world as a club player and as an internationalist. At that time, Huddersfield was an industrial town made up largely of cloth mills and was quite unlike Aberdeen, the Granite City, known mostly at that time for its thriving fishing industry.

My father was a fisherman and would sail out of this harbour for six days at a time, except when he went to the Faroe Islands, which was a three-week trip.

Whenever I return to Aberdeen, I visit Mike's fish and chip shop in Torry, make my way to Balnagask with my wife, Di, and enjoy the peace and quiet of this view over my home city. It is so close to the bustling harbour, always full of life, and yet it is almost like looking in from the outside.

A trip we often make from here is to drive down the coast to Stonehaven. I have many childhood memories of visits to the wonderful open-air pool in the summer, but these days, we always make for the picturesque harbour.

After a leisurely walk along the harbour front, we head over the Slug Road and visit the Falls of Feugh, just a few miles outside Banchory. The river can be spectacular after rain as it rushes through woodland and over rocks, particularly beautiful in autumn. We then complete our circular tour by driving back into Aberdeen along the South Deeside Road.

When Andy asked me to identify my favourite place in Scotland, I was undecided between Aberdeen Harbour from Balnagask and Stonehaven Harbour, but I opted eventually for this particular view because of its personal associations with my father and my deep affection for the city of my birth.

Andy has caught the atmosphere exactly as I keep picturing it. A perfect photograph that sums up everything that I remember about Aberdeen Harbour.

Denis Law

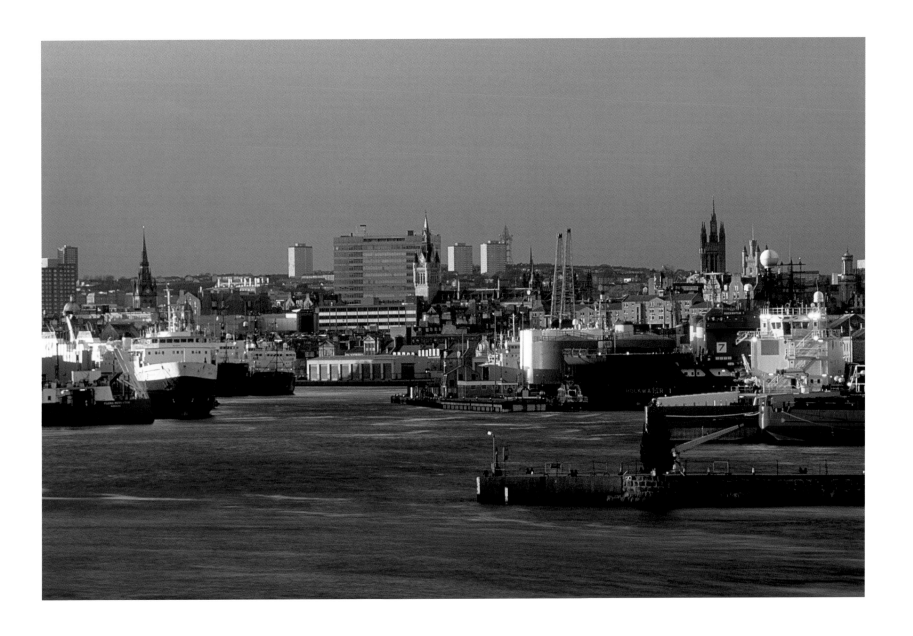

The River Tay, Perthshire

The favourite place of Ken Bruce

As a teenager I spent several summers during the sixties in and around Aberfeldy, Kenmore and Pitlochry.

I cast my first fly, drank some of my first beer and had some of my best laughs amongst the hills of Perthshire. The peace, the stillness and the security of the surrounding hills are all strong memories to this day.

If there is a more beautiful sight than the Tay meandering through the Perthshire hills, I've yet to see it.

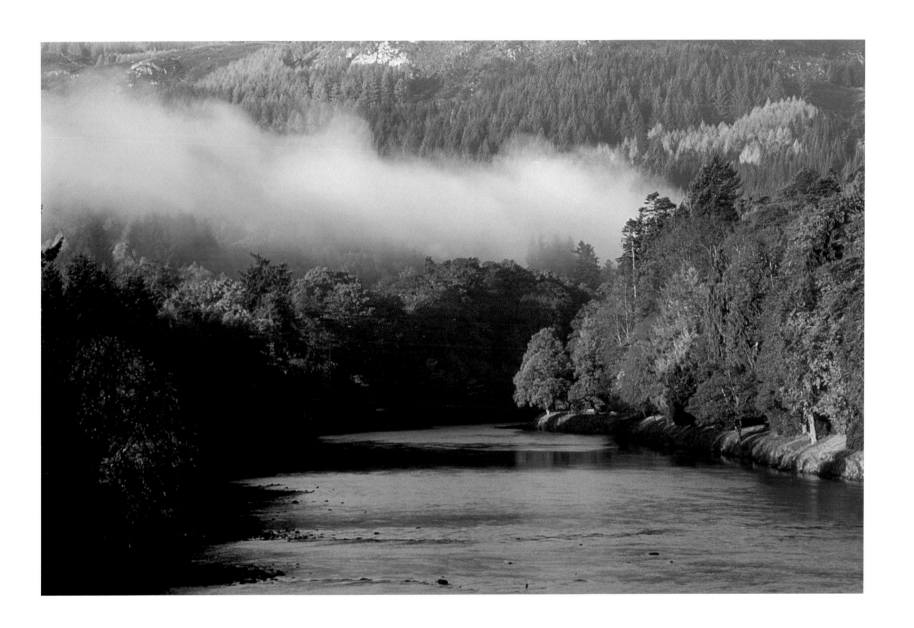

Ardverikie, Loch Laggan, Lochaber

The favourite place of Dawn Steele

When I first arrived at Ardverikie, this is the sight that hit me. The house itself has a driveway; not any normal driveway, though—a fifteen-minute car journey. It winds round the loch so, as you drive, you get the most amazing views.

This photograph of Ardverikie from the loch side means so much to me. It's hard to explain why, but it is so engraved on my memory because for seven months of the year (for five years!) it was the first thing I saw going to work and the last thing I saw on my way home.

A lot has happened on that beach, on and off camera! In the hot summers (yes, we did have a couple of days!) we had barbecues, swam in the loch (!) and sunbathed. While filming, we have had funerals, parties, deep family revelations, balls, highland gatherings—you name it!

We have filmed so many scenes here. Directors love it as it's such a fantastic backdrop. We used to feel a bit out of place in the scene, shoved to the side! I do miss it a lot. It's amazing when it's hot weather as you have this rugged Scottish countryside along with a bright white beach, but also mountains covered with snow! Although I've never been to New Zealand, I can imagine that this is maybe what it looks like.

This photograph means love, friendship, laughter and tears. Five years of it!

Dawn Steele

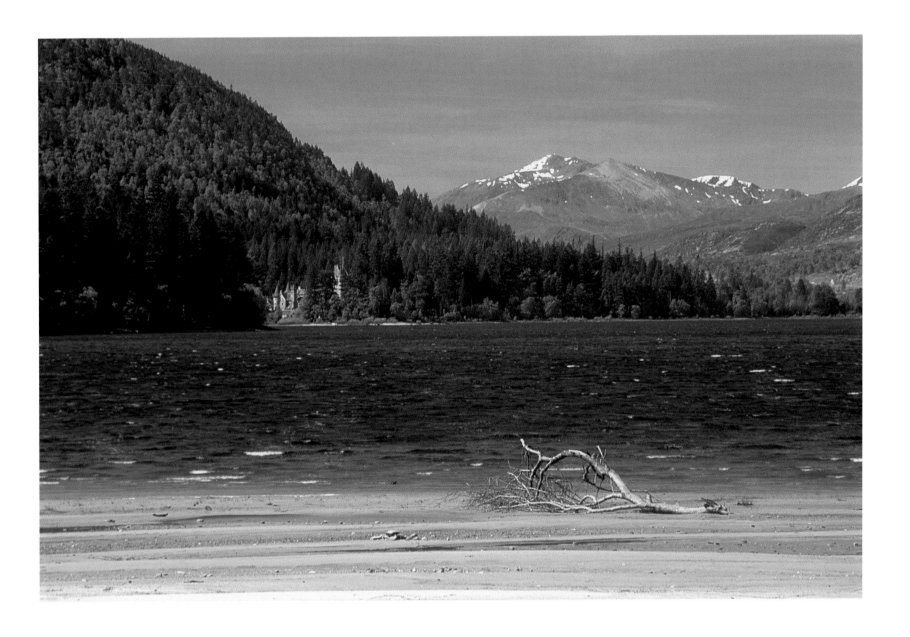

Drumochter, Perthshire
The favourite place of Alastair Mackenzie

The A9 snakes up and over the pass at Drumochter, the railway line beside it. Looking west, one sees swollen burns rushing down the hills and well-trodden paths forging deep into the wilderness.

This is a resoundingly dramatic place. I was brought up ten miles south of Drumochter, and then returned for four years to film *Monarch of the Glen* twenty miles to the north. These hills are as familiar to me as my knees. Yet every journey I take over the pass fills me with wondrous longing. I glance west and the very shape of the glen bids me to stop the car and walk: walk towards the light.

The Siren call of this wild land is always irresistible; it just sucks me in. I know Rannoch Moor is just beyond the horizon. Something powerful sings to me and it seems as if my soul is beckoned out of my chest and into the hills. Heaven is out there somewhere, I've just got to try and reach it.

If I travel up on the sleeper, I will set my alarm so as to be able to open the blind and catch Drumochter at dawn.

I have always felt that that there is something soft about this place, despite its rocky rawness. This photograph captures that. The heather seems to blanket the hard hills. I want to lie there basking in the evening sun, knowing that the rain is soon to come down from the hill beyond.

My heart is in this place. And it changes every time I see it, a shift in the light taking it from beautiful to foreboding in an instant. That is Scotland. And I love it.

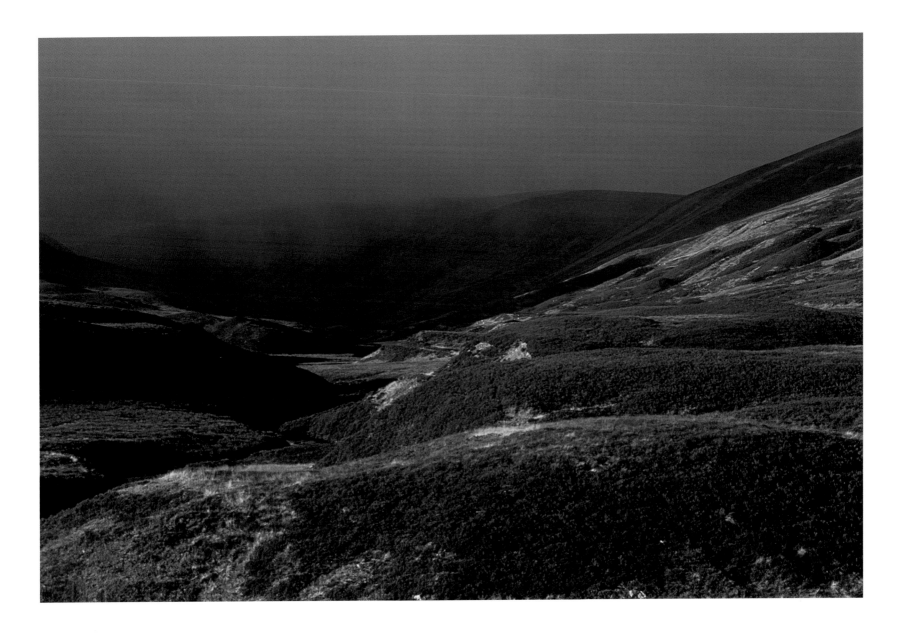

St Cyrus, Kincardineshire

The favourite place of Colin Prior

My favourite place is a difficult call. What sets St Cyrus apart from the others is the time I spent there as a child. We had a holiday home in Montrose and I was instinctively drawn to the cliffs and salt marsh.

Locally known as 'the Slunks', the whole basin flooded at high spring tides creating a rich habitat for wildlife and plants. Sea pinks and the lilac-coloured sea aster flourished and shelduck nested in disused rabbit burrows.

On the fore dunes, oystercatcher, ringed plover and little tern were common, establishing territories on the shingles surrounding the North Esk estuary.

At Gun Moo the basalt cliffs were literally alive with nesting herring gulls and fulmars during July and August, and in the gorse the distinctive song of the yellowhammer—'deil-deil-deil-tak ye'—could be heard. Occasionally a peregrine would swoop in over the cliff tops and send seabirds into panic.

Sadly, much has changed in twenty years—the seabirds have gone and the salt-marsh no longer floods, but it will always be a magical place to me—my own sort of Treasure Island.

Colin Prior

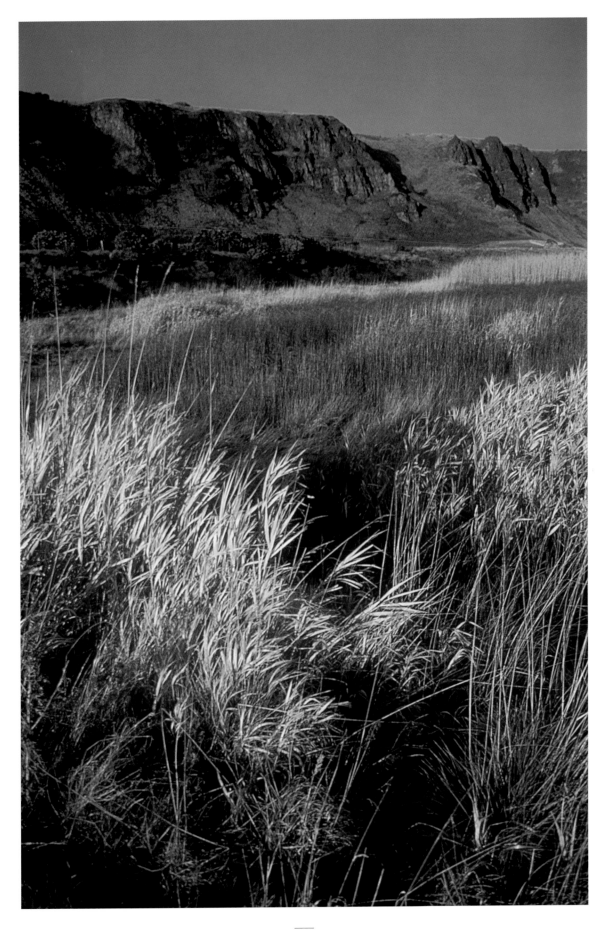

Tràigh Bàn, Isle of Iona

The favourite place of Sarah Heaney

The first time I visited Iona, it literally took my breath away. I thought that places like this only existed in dreams—it truly is the most beautiful, peaceful and spiritual place in the world.

Standing on Tràigh Bàn, one of many contrasting beaches on the island, I was mesmerised by the dazzling sands and the glistening waters as I breathed in the crisp sweet air. I only have to close my eyes and I'm there again…

Sarah Heaney

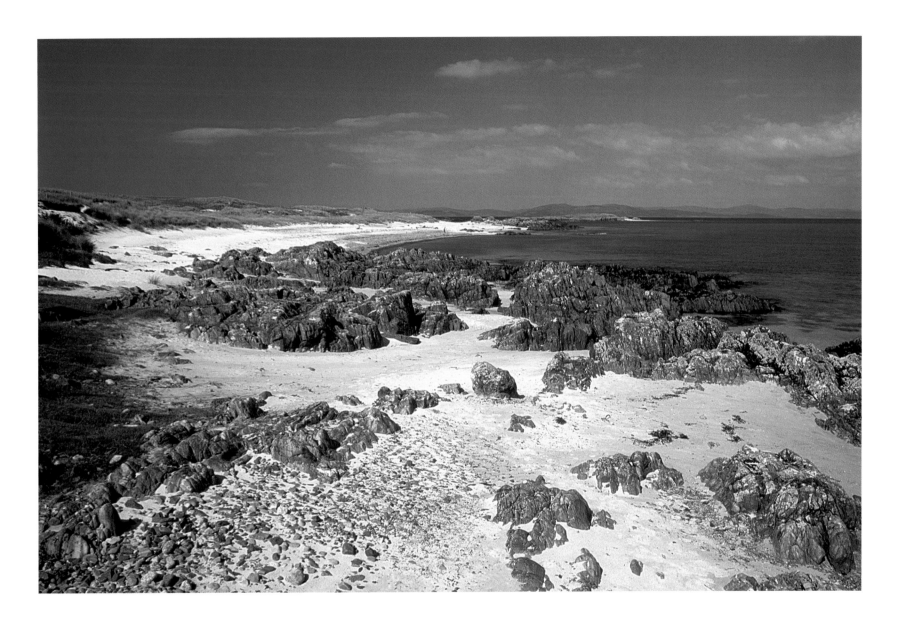

Greyfriars Monastery, Uddingston, Glasgow

The favourite place of Jimmy Johnstone

Over my life I have regularly visited Greyfriars Monastery and its beautiful grounds for a whole variety of reasons, but mostly for peace and quiet. I can't believe that this tranquil place is so close to the motorway. It amazes me that there is no sound of traffic at all to be heard.

On many occasions I have rung the bell in the small church behind the big house in the photograph and it would be answered by a Brother from the Franciscan Order who would invite me in for confession—though I would never see him. This has been a very important part of my life.

While walking through the grounds, I would meet a great many people who would stop and pass the time of day. I can clearly remember the statue of Our Lady in the corner of the garden overlooking the River Clyde which passes by the edge of the grounds on its way to the sea. Up until a year ago I continued to train and keep myself fit in the surrounding grounds of the Monastery.

The Brothers often said that the main house was haunted, and that they had some strange experiences within its walls with bells ringing and doors closing for no reason. All of this added to the fascination of the place for me.

Just as you come in the gate to the grounds, there is an old scout hall that is no longer in use. They used to hold discotheques there on a Sunday night. This is where I met my wife, Agnes. Even after all these years, we live only a mile or so away in Uddingston.

Andy's picture is perfect. The Monastery looks wonderful in full summer foliage but in autumn the colours are stunning. It's exactly the way in which I'd like my special place to be featured.

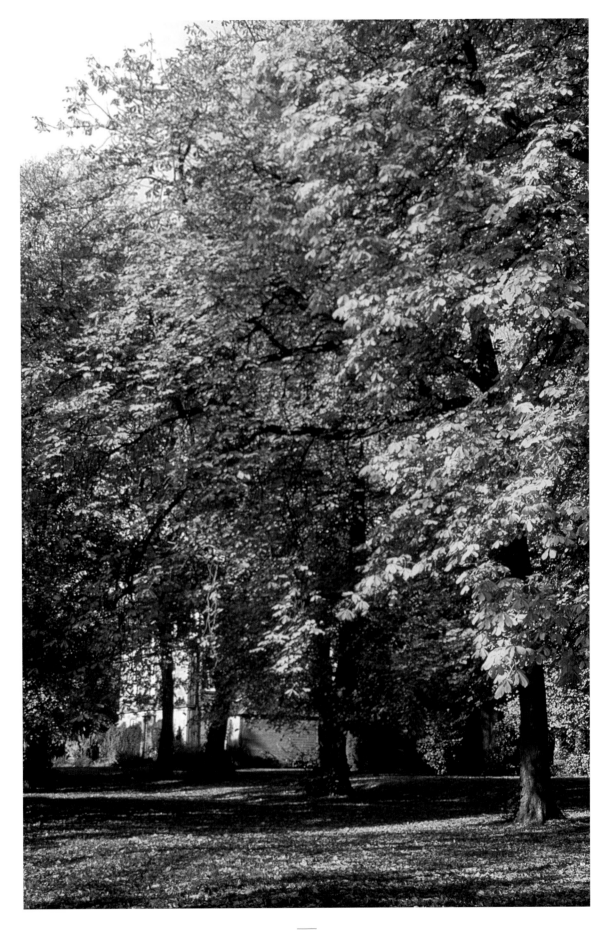

Loch Etive from Taynuilt, Argyllshire

The favourite place of Karen Matheson

Growing up in the little village of Taynuilt on the shores of Loch Etive was a magical experience. This picture stirs wonderful childhood memories of long summer days searching for crabs, chasing swans and eating cheese and tomato sannies (filled with sand) under the imposing beauty of Buachaille Etive Mòr. In later years it was beach barbecues and birthday parties on the boat, *Anne of Etive*, with trips up the loch to watch the sunset while otters ducked in and out of the rocks.

I was recently involved in filming a TV programme which required me to row out to the middle of the loch (with a little help) and watch the sun come up. The scene was breathtakingly beautiful, a crisp December morning, sunlight dancing on the water and mountains capped with snow. Time literally stood still. To steal a phrase from a friend and great songwriter James Grant, 'If I see this picture when I die I'll know I've landed in heaven.'

Karen Matheson

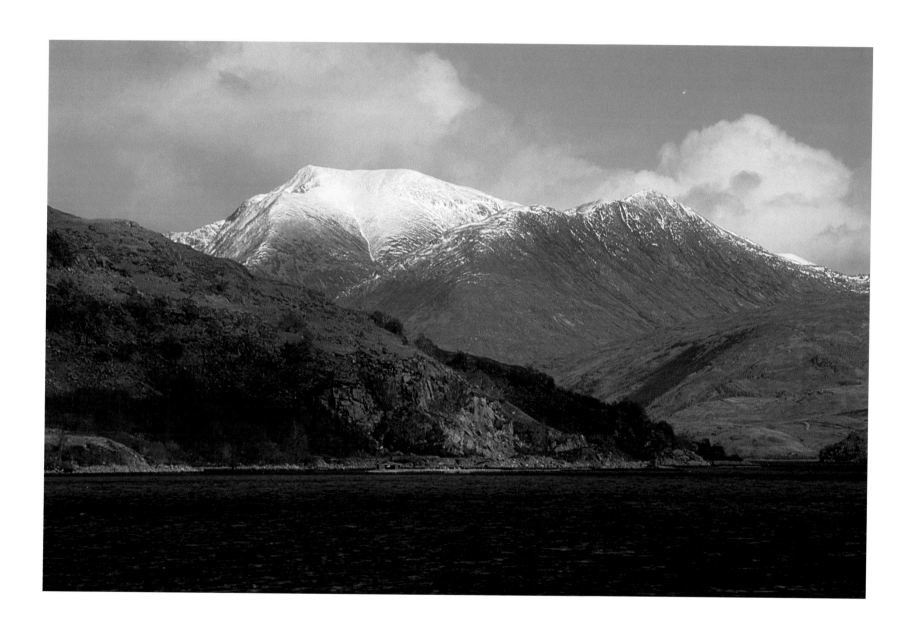

Arran Skyline, Ayrshire
The favourite place of Hugh McIlvanney

As somebody born and raised in Ayrshire, I have always had the outline of Arran against the western sky as part of the furniture of my spirit. My deep attachment is not to the island itself, though on visits there I've found it easy to appreciate the charms that have captivated other contributors to this series.

What is special for me is the sight of Arran from the mainland shore, its central presence in the majestic sweep of the Firth of Clyde, a place I have never ceased to regard as magical.

I think the vistas of the Firth are not only uniquely Scottish but, in their contours and the changes of light and perspectives, very much of the west of Scotland. Naturally in me they stir feelings of family, memories of youth, all the thousand and one effects that come with a sense of belonging.

But I believe a stranger, too, might be moved, especially if he or she looked out from the Ayrshire littoral around Barassie and Troon, as Andy Hall did to take this heartbreakingly beautiful photograph, and saw Arran and the dozen miles of intervening sea bathed in the last rays of the setting sun.

It is, of course, a view of many moods, and Arran is liable to do a Garbo and disappear altogether behind a wall of mist. But that just makes its re-emergence as welcome as seeing the face of an old friend you have been missing.

Work has caused me to be away from Scotland most of my life, but I have made a point of being a frequently returning native, so my Scottishness hasn't required strenuous maintenance. If it ever does, I'll look at Andy's picture.

Hugh McIlvanney

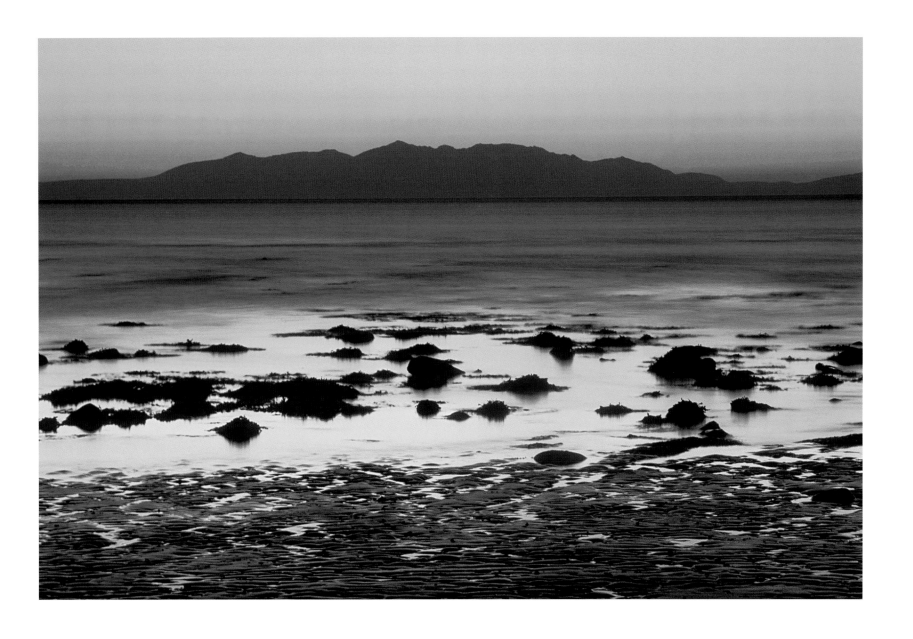

The East Coast of the Isle of Harris

The favourite place of Dame Elizabeth Blackadder

My visits to the Isle of Harris made a deep impression on me. Visually, it was quite stunning. The contrast between the east and west coast is quite marked, and to me the barren, rocky east coast was more striking. Perhaps these bleak, stark landscapes reminded me of my favourite early Italian paintings.

They lie south of Tarbert, along the 'Golden Road' (a far cry from the other Golden Road), a twisting, narrow road beside rocks and peat cuttings, and look east towards the island of Scalpay. Beyond, in the distance, lie the Shiant Islands.

At dawn, a pale yellow sky would gradually illuminate the dark shape of the islands, the light changing all the time, quite fantastic. In the distance, smoke from a passing ship, or did I only imagine that in a painting? Forever changing light and weather—perhaps an eagle hovering overhead, hardly moving.

This beautiful photograph brings it all back.

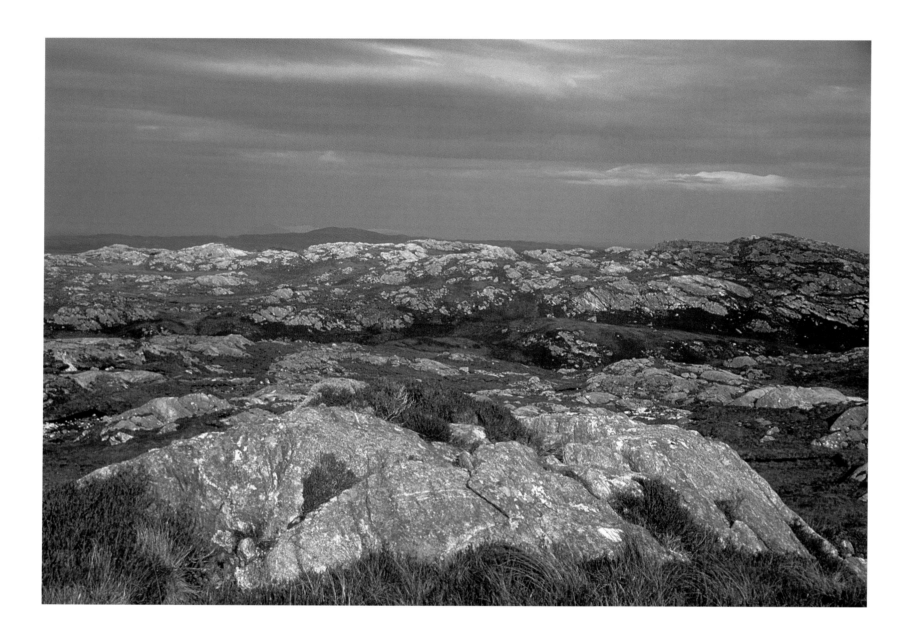

The King's Course, Gleneagles

The favourite place of Alan Hansen

Andy's beautiful photograph encapsulates everything I feel about Gleneagles. For me, it is a combination of golf and heaven. I was brought up in Sauchie, only half an hour away.

Golf is my first love. There is no better place to play than Gleneagles with such beautiful scenery surrounding the course. I'm very competitive, and always want to win, but at Gleneagles losing doesn't seem so bad, and that's saying something for me.

This lovely photograph, looking back towards Glendevon, will always serve as a reminder of this wonderful place. Anyone who has never played at Gleneagles is seriously missing out!

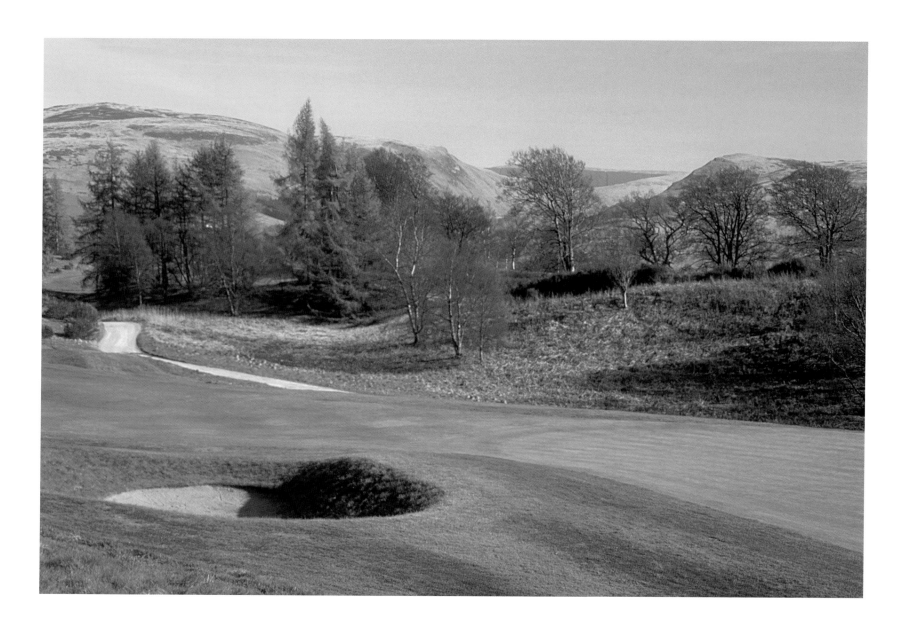

Pattack Falls, Strathmashie, Badenoch

The favourite place of Phil Cunningham

I stumbled upon this magical place on my first ever venture into the Highlands. On board the band bus and not expecting a scenic encounter, I found myself in a lay-by following a call for a 'rest' stop.

Whilst waiting for the others, I took a wander and had my first meeting with highland waters. It was one of the very rare occasions in my life where I was left speechless.

It still defies my ken, how something so dark and powerful can instil in me such a sense of peace, tranquillity and wonder. Since that day, I visit every time I'm near.

The ever-changing light ensures that it never looks the same twice, but it never fails to evoke that unforgettable feeling that started my love affair with the Highlands.

Andy has managed to capture the very essence of what I saw that day in this beautiful shot. That unique light, immense power and serenity… all rolled into one.

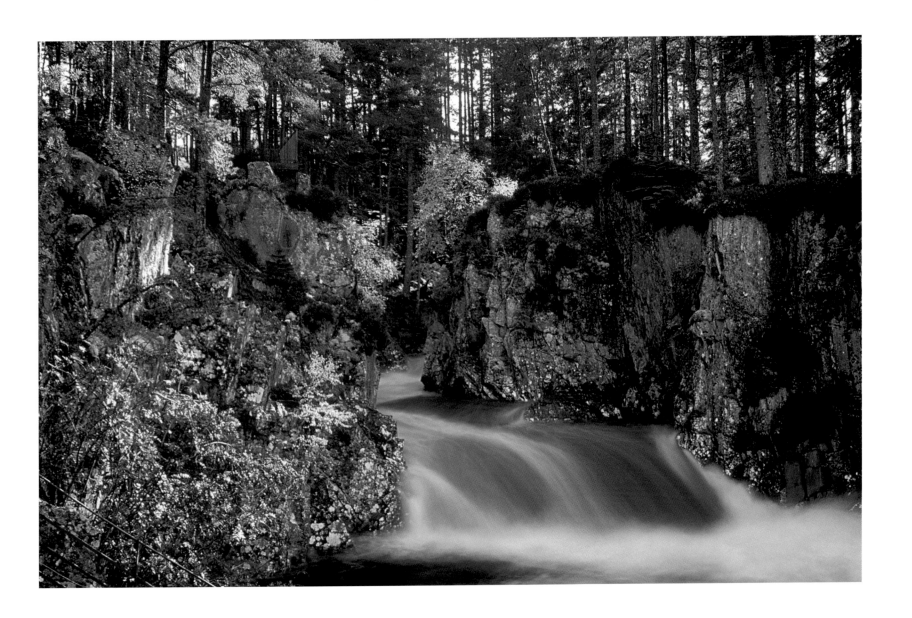

Clachan Sands, North Uist

The favourite place of Calum Macdonald

We all have our special places of sanctuary and contemplation, where the natural world becomes a temple and where the physical and spiritual landscapes unite.

I have been coming to Clachan Sands all my life, and I have seen this place in all its changing moods and myriad contrasts. From the expansive arc of the bay, round the rocky point to Hornish, looking across to the island of Lingay and the rolling hills of Harris. From the two cemeteries denoting two eras, to the green, gentle swathes, flecked with wind-blown sand and wild flowers.

This place is special and personal, because it has always carried the lives of my ancestors. From the final resting place of generations, to the present lives that live and love and work the machair lands.

When you are here, you are beyond the restrictions of time, you hold the past as much as you wonder at each passing second, catching fleeting glimpses of the light that moves us on to something infinitely greater.

> *The light is on me, all time is here*
> *I'm going down to Clachan to stem the rush of years.*

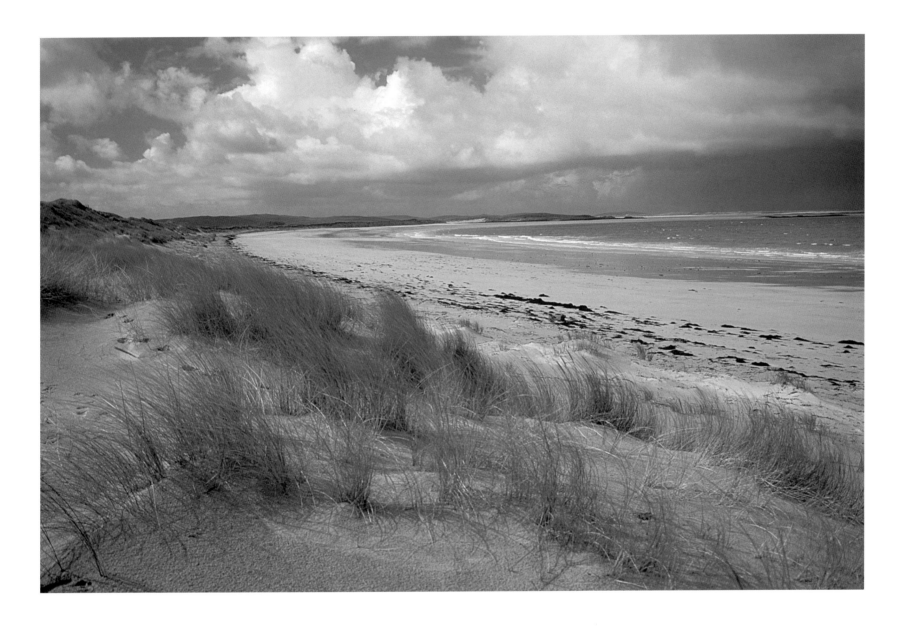

Glen Afton, Ayrshire

The favourite place of Sir Tom Hunter

When Andy Hall asked me to name the place that resonated with me most in Scotland, I didn't hesitate—Glen Afton in Ayrshire. Many might say it's not the most beautiful of spots in Scotland, but to me it tells a huge story.

Growing up in New Cumnock, our lives were dominated by the coal mines, many of our families knew of nothing more. School for us then was claustrophobic, meant nothing to us and prepared us for one destination—yes, you guessed it—a career down the mines. The careers officer didn't have a tricky job!

So when me and my mates like Rab the Rhymer—still a great friend to this day—got off school we'd 'beat it' and march out to Glen Afton. It was space, freedom, opportunity and a chance to open our minds, to dream of what could be, rather than what would be. It opened our horizons, only for school to then close them for us.

To this day it reminds me of why I'm so passionate about Scottish education being fit for purpose, opening minds not closing them, and giving every kid an opportunity to shine—to be all they can be.

As for us, Rab headed to meet his pre-destined role down the mines and I went my own way thanks to my dad. Today, Rab is one of Scotland's best poets in my opinion—it took him twenty years to discover it. I wonder where he'd be now if our education had been a little different then?

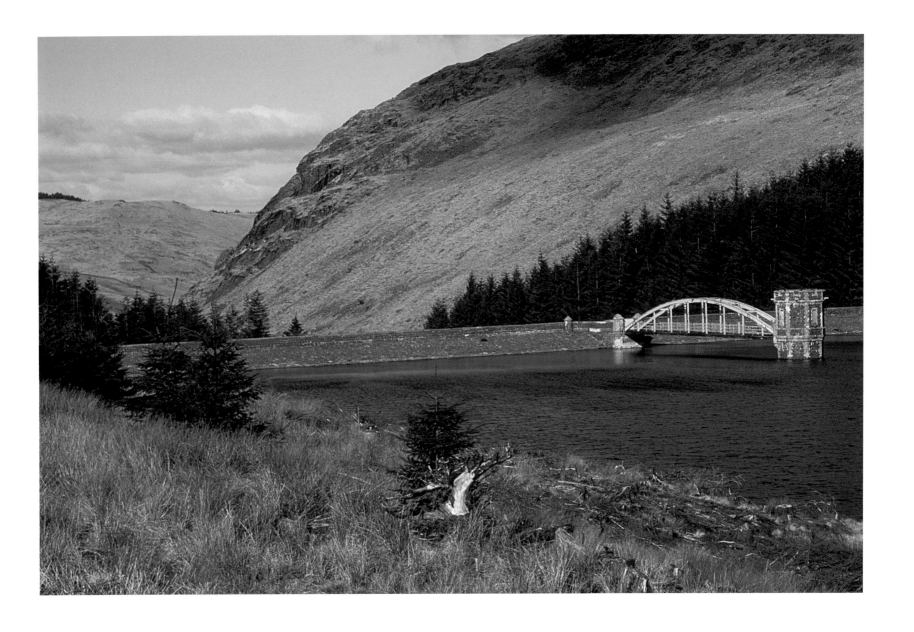

Lossiemouth, Morayshire

The favourite place of Dr Winnie Ewing

My most courageous act was to become the SNP Candidate for Moray and Nairn, to leave my comfortable, familiar Glasgow home and my well-entrenched Glasgow society, and I have no regrets. I was a stranger and they took me in.

I bought a tiny house on the Square in Lossiemouth, effectively I moved in amongst fisherfolk, well warned they would accept me or reject me. This new town, of the broad streets and the fishing harbour and market place, never stopped providing me with thrills. Happily, I was accepted and was very proud of this.

Also, of course, I had the joy of the scenery of Lossie—the two beaches, and all around lovely towns and villages of infinite variety. The world of the farmer also became my world of concern.

The people of Moray have a great sense of wit and fun and of egalitarianism. There is no more point in having airs and graces in Moray than in Glasgow.

As I joined Moray Golf Club, Findhorn Yacht Club, Nairn Sailing Club, Elgin Operatic Society, the welcome was warm.

Early mornings I often used to rise and have a stroll to the harbour. Saturday mornings usually meant an anonymous 'fry' of fish on my hall tray.

Delights galore were contained in the memories of the fishermen who had followed the fleets round the Northern Isles and to Wick, and the memories of women who served as maids in 10 Downing Street for Ramsay MacDonald. My academic husband on retirement came to live in Lossie and after his death I will never leave Moray.

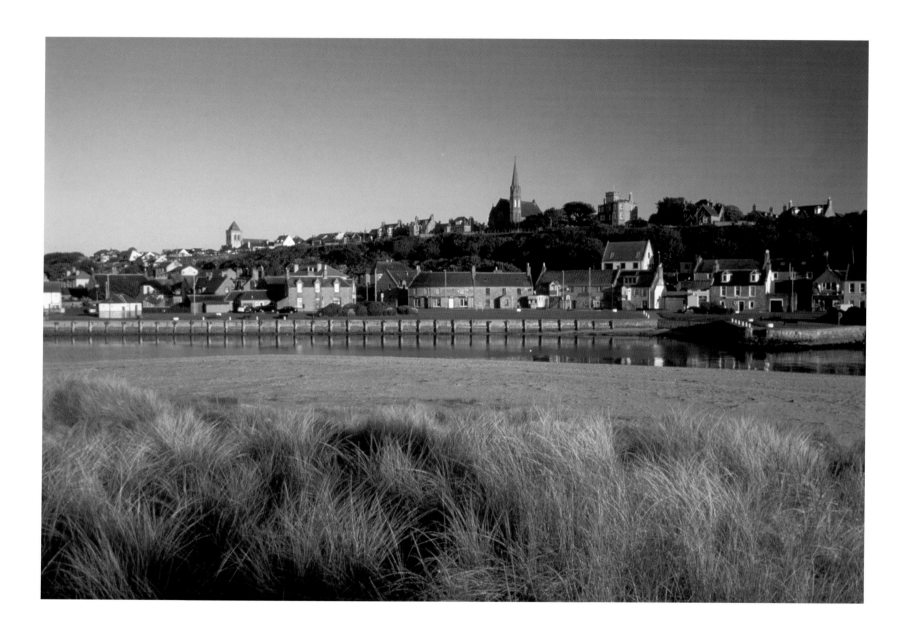

Ibrox Stadium, Glasgow
The favourite place of Alastair Johnston

Growing up in Glasgow, I always recall my Dad referring to the red-brick facade of Ibrox Stadium as 'the bricks and mortar that guard a cherished past'.

This was indeed the portal that towered over the playing field where on many memorable Saturday afternoons the relative success of the charges of the 'men in the famous light blue' would determine your mood for several days; whether or not it was even worthwhile going out with your girlfriend that night, and, most assuredly, whether or not you would be the purveyor or the victim of the bragging and harassment that would inevitably be encountered at school, college, or work on the following Monday morning.

There was something solid and reassuring about the edifice at Ibrox. For many Scots, it was a symbol that bore a direct connection to your father and grandfather before you and probably to your own son and grandson as they, in turn, would be forced to listen to the tales of heroics from 'bygone days of yore'. (No matter how 'blue-tinted' these recollections proved to be.)

This particular photograph displays Ibrox under the typical grey, foreboding skies that were so predictable and prevalent in Glasgow that they, along with ambition and adventure, motivated me to emigrate to sunnier climes. However, as my mind drifts back to Govan, as it inevitably does on match days, no matter where I am in the world, I can only see in my own mind blue skies over the stadium on every occasion when Rangers triumph.

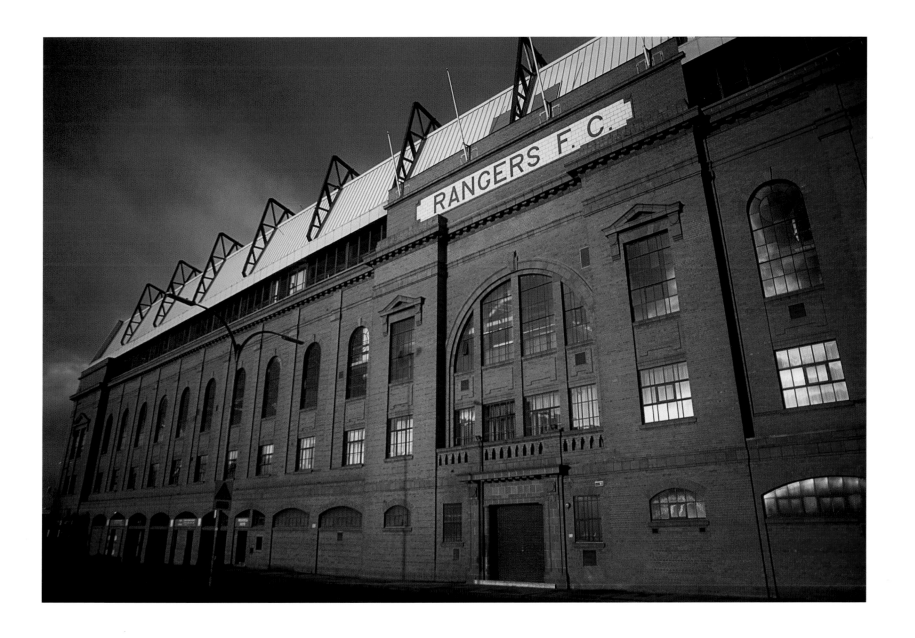

The West Coast of the Isle of Harris

The favourite place of Calum Kennedy

As a young boy growing up in Oronsay on the Isle of Lewis, I was fortunate to have the space and freedom to run and play by the sea. I was ten years old when my parents arranged for me to go to primary school in Harris where I learned to speak English—at least English with a Harris accent!

I remember being amazed by the difference in the landscape there. I love Andy's photograph because it shows Harris in all its glory and transports me back to my childhood. The seashore, the light, the freedom. I had not a care in the world… so many happy memories.

Calum Kennedy

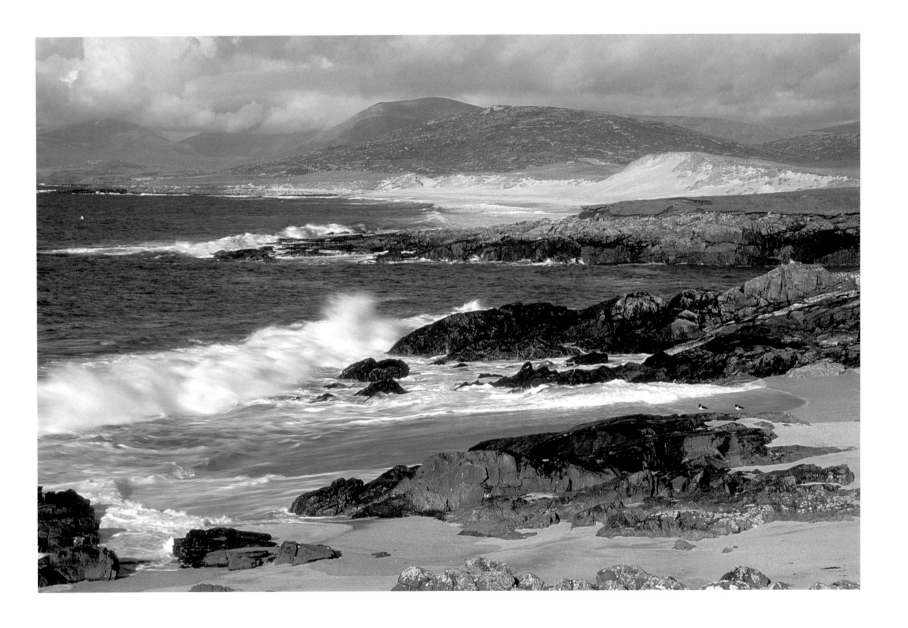

The Whinney Hill, Arthur's Seat, Edinburgh

The favourite place of Richard Demarco

The topography of Edinburgh is defined by its seven hills. The largest and most impressive is known as Arthur's Seat. It rises, in the shape of a gigantic lioness, to a height of almost one thousand feet. From its summit, a 360-degree view of Scotland's Lowlands and Highlands can be enjoyed.

However, my favourite vantage point on Arthur's Seat is not from the summit, but from the Whinney Hill at a height of 600 feet where the modern urban landscape and the suburban cityscape are hidden by the undulating grassy slopes upon which you find yourself walking in search of a view of Salisbury Crags.

Standing here, you see directly before you Edinburgh Castle as the focal point in a primeval tree-less landscape, formed by the great upsurge of a volcanic explosion which gave Edinburgh all its hills. You are looking at the steep northern slopes of a valley rising above the Hunter's Bog, and on it are the unmistakable tracks of countless generations of men and animals. These are like large drawings on the earth's surface. They lead your eye to the only man-made structure in sight. It is a veritable citadel made manifest by Edinburgh Castle's medieval walls. They are protecting the residence of kings and queens of Scotland which came into being many centuries before Holyrood Palace.

It is on these slopes of Arthur's Seat that I have begun many journeys in the spirit of exploration and pilgrimage, leading the students of the Demarco Gallery's 'Edinburgh Arts' Summer School, together with teachers from Edinburgh University's School of Scottish Studies, and artists such as Joseph Beuys, Günther Uecker, Marina Abramovi, Ivan Illich, Paul Neagu and Per Kirkeby. I planned these journeys to help alter the course of Scottish art by incorporating the prehistoric monuments of Callanish and the Ring of Brodgar, statements which aspire to the condition of sculpture, whilst acting over many millennia as megalithic lunar and solar observatories.

Beyond Corstorphine Hill lies the quintessential 'Road to the Isles'. It is a drovers' road and it was travelled by Roman legionaries and their Pictish adversaries as well as Celtic saints and scholars. I recognise it as 'the Road to Meikle Seggie'. Now designated as a farm, Meikle Seggie was at one time one of Scotland's villages—a lost settlement which we cannot afford to forget if we take seriously the Scotland celebrated in bardic poetry, folksong and travellers' tales.

Andy Hall's photograph brings into sharp focus that dramatic moment when the first image of Edinburgh Castle appeared unexpectedly, growing organically out of a timeless primeval Scottish landscape. Looking closely at the photograph, you can see the world of Macbeth, Mary Queen of Scots and the Celtic and Roman inhabitants of Arthur's Seat.

This photograph could be part of your dream as Camelot come true. Under the bright light of summer morning sunshine, there is revealed the reality of a landscape in which history and mythology are inextricably intertwined.

Richard Demarco

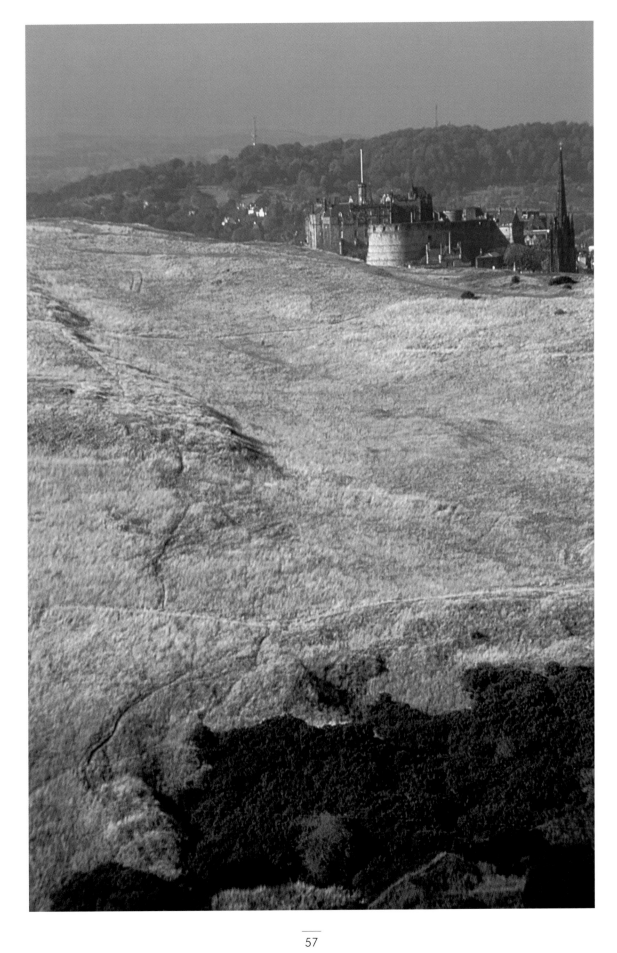

The Wallace Monument, Stirling

The favourite place of Kenny Logan

My family farm sits underneath the Wallace Monument. I had lived there all my life until I moved to London in 1997. Every day I woke up and it marked the horizon in rain, sun or snow.

I loved the fact that when I left Stirling I could describe where I lived by the Wallace Monument. If people had been to Stirling they knew where I lived by the monument location.

In 2000 I proposed to my now wife at the top of the monument. She jokes that if she had said no, she might have had to jump off rather than walk down the steps.

The monument is a man-made structure but it is the scenery and hills around that make it so special. After the film *Braveheart* they built a statue of William Wallace at the entrance to the Monument. It's uncanny how much he looks like Mel Gibson!

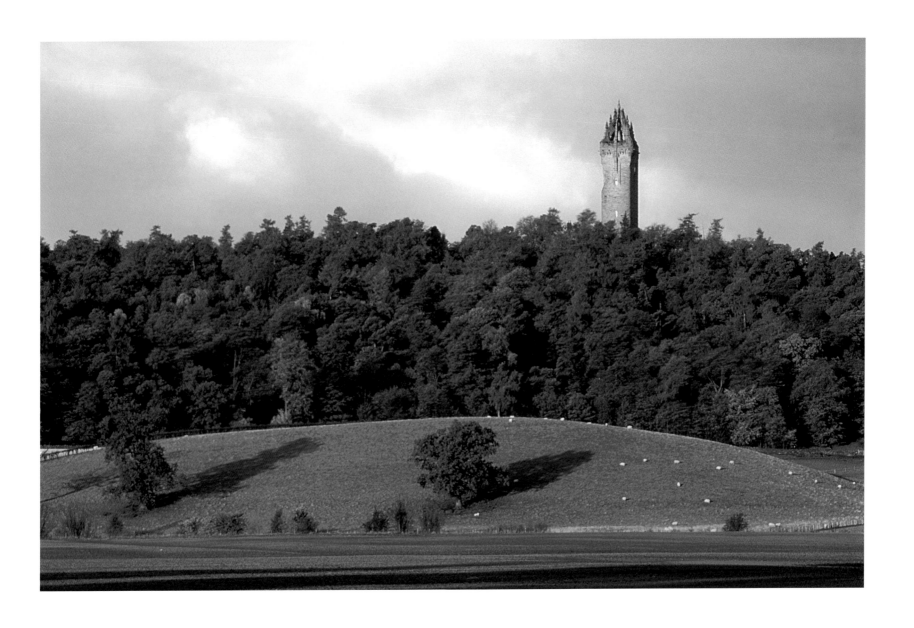

Gribun, Isle of Mull

The favourite place of John Lowrie Morrison

My favourite place on earth—
 Gribun, Isle of Mull.
 Gribun of the thousand-foot cliffs.
 Gribun of the shafts of light.
 Gribun of the folklore.
 Gribun of the eagles and sea eagles.
 Gribun is primeval. Dark foreboding rock—strong light and even stronger colour.
 A feeling of standing on the edge of the world!
 Andy has conveyed this contrast wonderfully well—darkness versus colour—which is what my paintings are about—an allegorical description of the human spirit, if you like!
 Gribun just makes me feel the touch of the creator—the light—the colour—the wind. My best experience of Gribun was in a January gale with the wind and snow roaring like all creation was heaving.

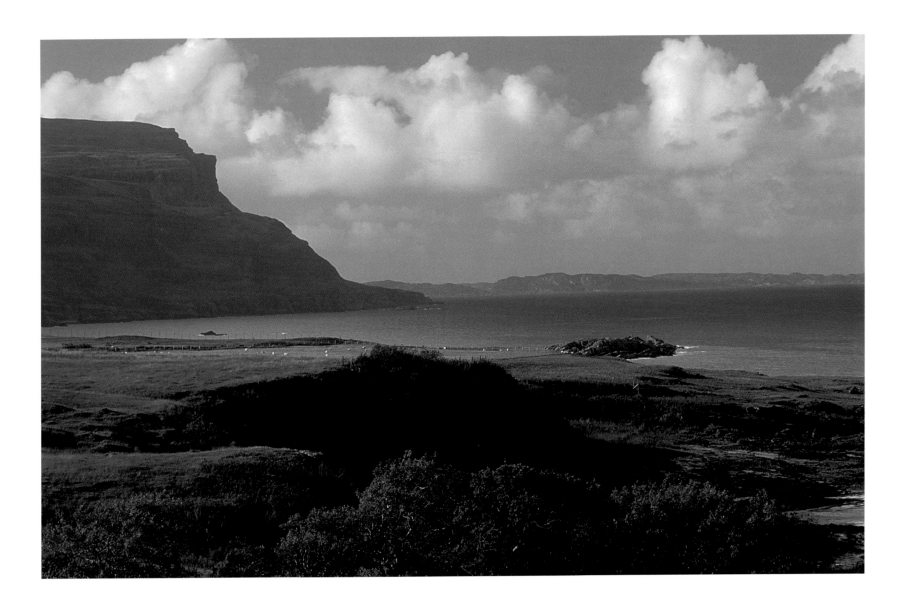

Edinburgh Castle at Night

The favourite place of Louise White

In my childhood Edinburgh meant nothing more to me than the zoo. In my twenties I loved the shops and, call me a late developer, but it has only been in my thirties that I have truly begun to appreciate Scotland's jewel.

In recent years I have had the opportunity to report for Scottish TV on events around the city, such as the opening of the Parliament and the annual festival in August. Every time I make the journey from my home in Glasgow I see it in a different light.

However this photograph of the castle by Andy means much more to me on a very personal level. Work commitments prevented my husband Geoff and me from celebrating our wedding anniversary last year. It was postponed until November and we marked the occasion by spending a weekend in Edinburgh.

Late on the Saturday night, after dining at a restaurant close to the castle, we walked up to the esplanade. Gone was the mayhem, the visitors, their cameras and the tour buses; we only had the chill breeze and the stars for company. For once, there was no deadline, no script to write, no one to interview, just the chance to enjoy the midnight views and absorb a moment in time that will stay with me for the rest of my life.

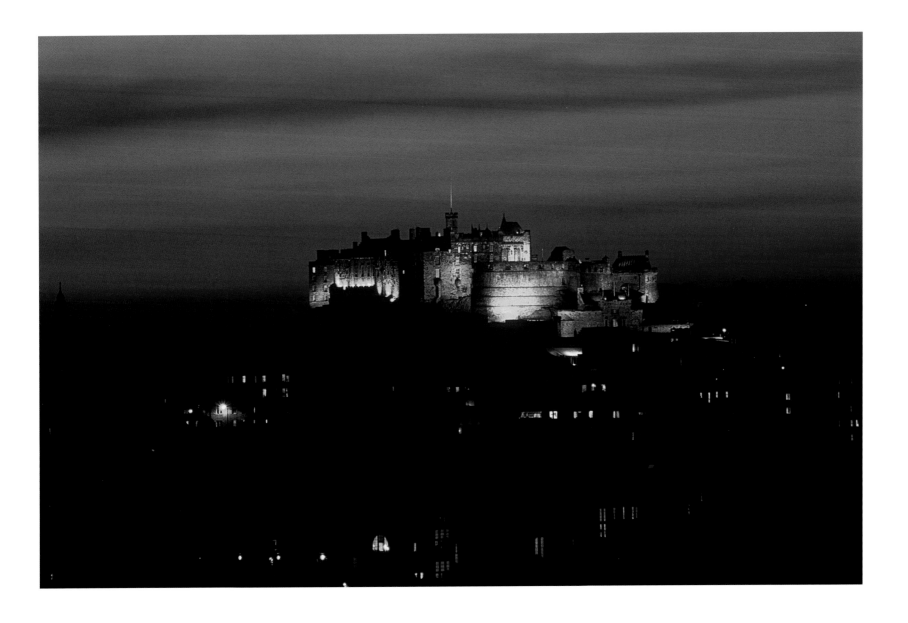

Kilbride Bay, near Tighnabruaich, Cowal

The favourite place of Jackie Bird

I first stumbled across Kilbride Bay twenty years ago when visiting nearby Tighnabruaich. The locals call it Ostel Bay, and it's one of their best-kept secrets. The horseshoe-shaped bay can only be reached by a walk of about a mile cross-country, the last part of which is a bounce across peat bogs, dodging ankle-breaking rabbit holes as you go. However the beauty and serenity that await you are well worth the trek.

The bay is about 400 metres wide. It nestles between the Argyll hills on one side, a rocky outlet on the other, with the majesty of Arran in front.

The sea-bed is flat for a good distance, which means that on a sunny day the incoming tide warms up nicely, allowing you to attempt that rare pastime—a swim in Scottish waters.

However the bay is also as breathtaking on a chilly November morning, or a dreich rainy afternoon in March, as it is in the height of summer. It must be the sense of being cosseted by the land—it's a comforting place.

It's also a place of many happy memories—of romantic walks, family picnics, of my dad giving his pink-faced, tired-out grandchildren piggy-backs across the dunes back to the car.

Andy's photograph has captured the seclusion and tranquillity of the landscape. The colours are incredible. The framing of the walk to the beach using the long grass is so welcoming—an invitation to a spectacular wide-screen production.

I know there are grander beaches in Scotland where the sands are whiter, the water more blue, but for me Kilbride is not only a place of beauty, it's got soul.

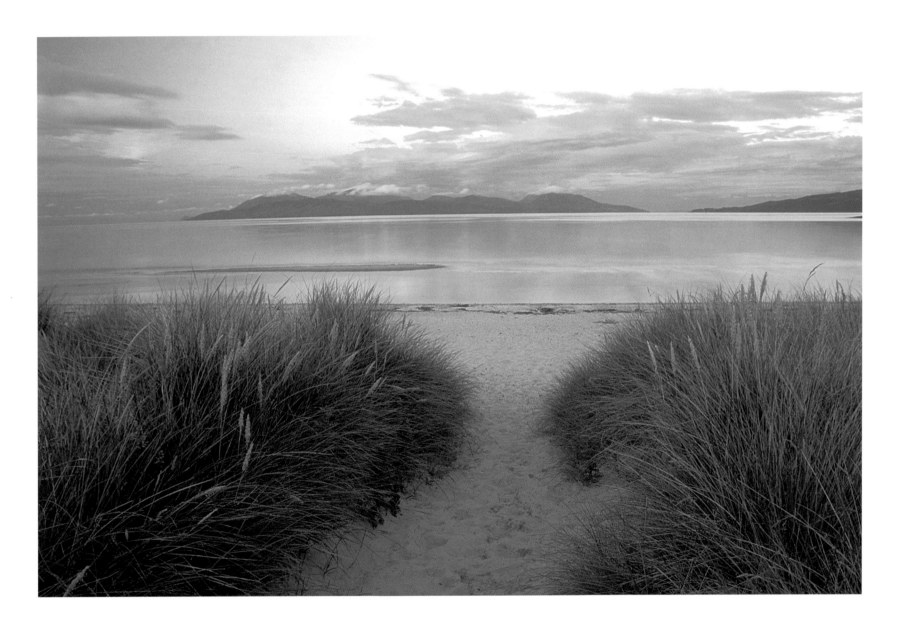

Silverknowes Golf Club, Edinburgh

The favourite place of Gordon Strachan

This is it! Young Strachan's world in the sixties, and I knew even then that this was a special view. Sitting on the steps of Silverknowes Golf Club on a warm summer's evening in the late sixties, trying to track my father's finish to his round of golf, was usually the end to a fun-packed day.

Hours of football with my mates or maybe a round of golf with the same lads; sometimes both were accomplished, always with the view of the Firth of Forth as the backdrop. I wondered where the big boats were going, where they had been and what they were carrying.

Today, when I sit here, I can still smell the grass stains on my jeans. I can still feel the warm breeze against my face, wondering if my dad will ever get a birdie four up the last.

Gordon Strachan

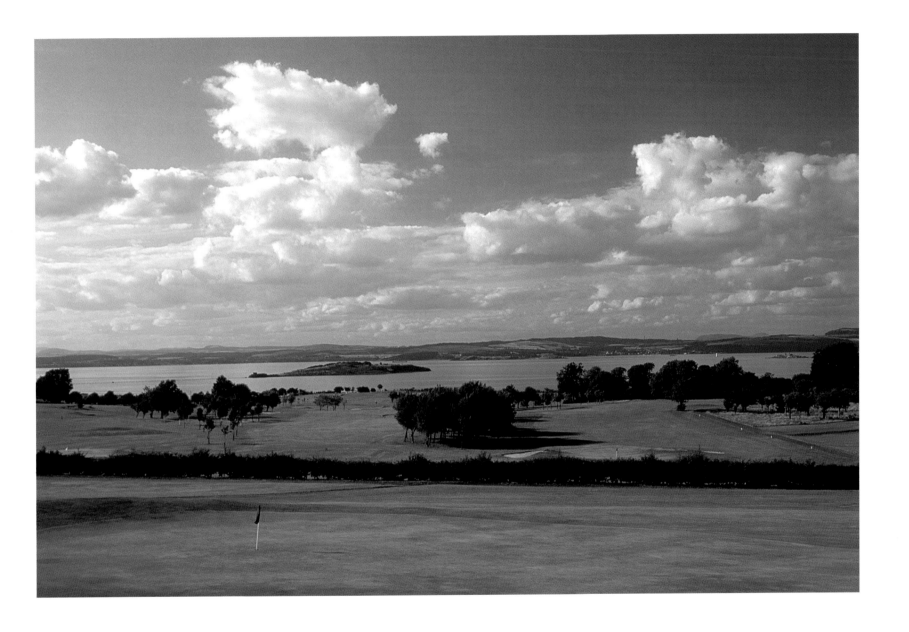

Lunan Bay, Angus

The favourite place of Isla Dewar

There is a stillness about Lunan Bay. We used to walk along that shore a lot, having long rambling mobile conversations. We rarely saw a soul. There is always something magical about having a beach to yourselves.

Years ago, we brought in New Year there. This photograph brings that night back to me, not just how it looked, but how it smelled, sounded. It was cold, and wonderfully clear. Not surprisingly, there was nobody else about. The moon spread long, shimmering paths on the sea. The sand looked bleached. Looking at the picture, I am back there with the smell of salt air, sounds of water and the odd gull floating, white in the darkness.

But more than all that, I can recapture vividly the very keen specialness of a moment. Two of us, on a beach, waiting for a new year to start, knowing that soon our lives would change. We toasted the bells with coffee from a flask, and shortbread. Four days later my son was born. In years to come we'd take him, and later his brother, to join our mobile conversations there.

Isla Dewar

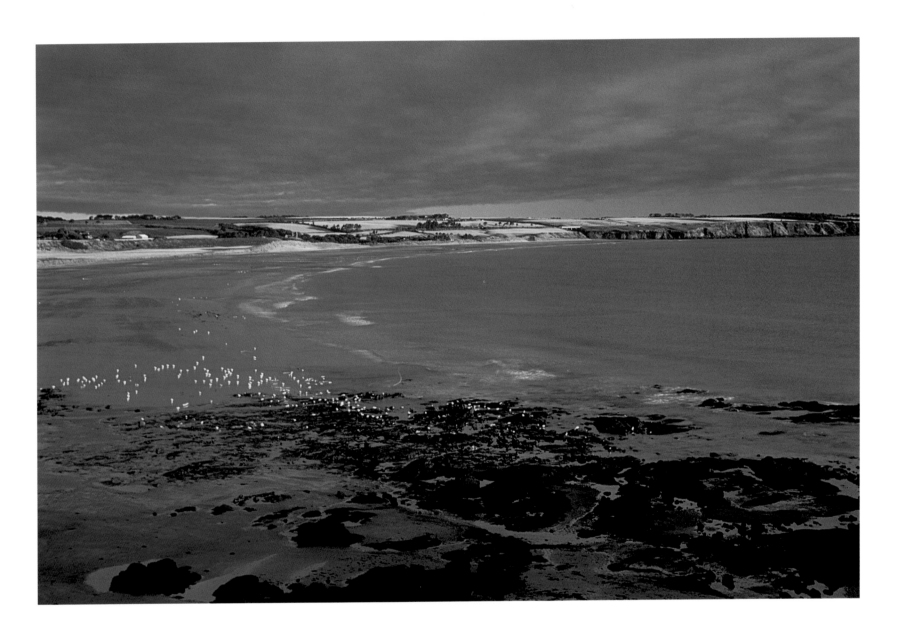

Greenock

The favourite place of Alan Sharp

Greenock's location, where the Clyde widens to estuary, has always been its crowning glory, what elevated it from a modest provincial town to one of the holy places, worthy of bardic celebration.

As a boy, this view, minus half a dozen high rises, would appear as we trampled home from the hills, foot-sodden, sock-ruined, with the aroma of the gorse macaroon-sweet in the air.

We did not linger long to savour its splendours: the hope of Welsh rarebit for tea and the urgings of gravity sent us hurtling homewards, unheeding.

But the imprinting remains metaphor as much as memory; the town clustering, the river flowing, the hills abiding; a secular psalm, the true place you will not find down on any map.

We, all of us, attach significance to our origins, or shaping source, sometimes embittered, sometimes sentimental, often both. My own feelings are best expressed in the town song whose doggerel can still be sung with genuine emotion these many years later:

It's been a while since I was there
In dear old Greenock Toon,
But I'll be going back again
An' I'll be going soon.
I'll look oot across the Clyde
High flowin' tae the sea,
An' I'll hear the birdies singin'
In the Green Oak Tree.

Alan Sharp

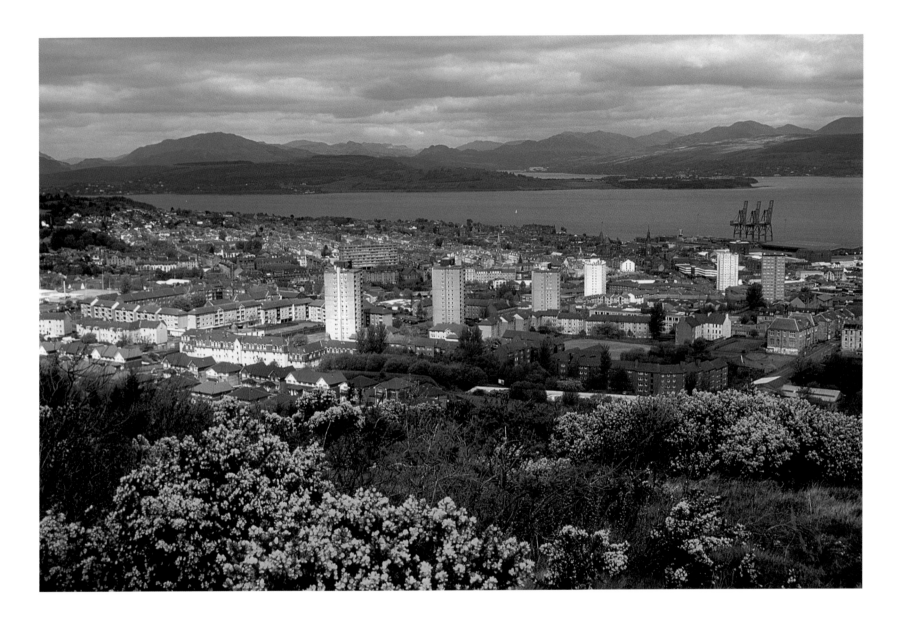

Loch Tummel, Perthshire

The favourite place of Sir Ian Wood

Bohally House on Loch Tummel in Perthshire is our new weekend home—an ideal country retreat which will be well used by our extended families.

The view up the loch from Bohally is almost a mirror image of the famous 'Queen's View'— a magnificent vista with the shimmering soft light on the vast loch surrounded by the majestic beauty of Scottish mountains, forests and open moors. It is truly a 'rest and be thankful' home, soothed by the constantly lapping water, the shrill cries of the bird life (ospreys nesting just across the loch), the swans, the geese, the ducks, and the vast array of wildlife.

Andy has captured all of this magnificently in this sunrise shot looking up the loch—the beauty, peace and tranquillity of a breaking dawn on Loch Tummel.

Daylight brings a kaleidoscope of changing colours—all shades of green, yellow, brown and blue—depending on the time of day and the changing weather. On a sunny day, with the rays dancing over the loch, this is one of Scotland's great beauty spots.

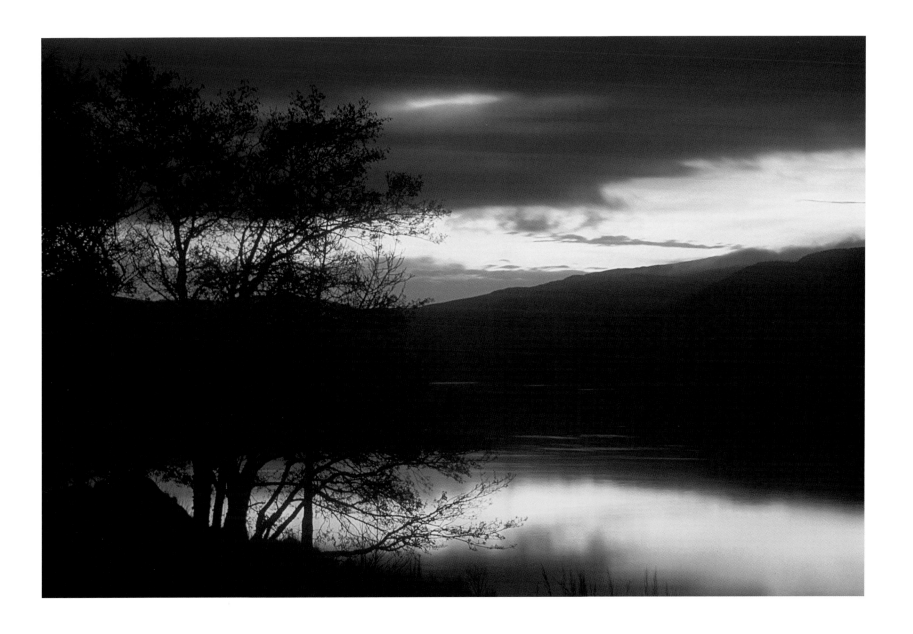

Aberdeen Coastline
The favourite place of Willie Miller

Since I was 16, I have enjoyed the Aberdeen coastline. It is a part of Aberdeen that I have used both professionally and recreationally. It is an area of outstanding beauty, irrespective of the prevailing weather conditions.

With Pittodrie only a stone's throw away from the coastline, it is a place Aberdeen Football Club takes advantage of for the training and rehabilitation of injured players. It has been used in bad weather in the depths of winter when no other facilities were available to us—as long as the tide was out, of course!

And in rehabilitation, I have had my fair share of jogging in the icy water to aid the healing process, and on every occasion I have been struck by the natural aspect of the coastline, whether the sun was shining or wild waves were thundering towards the shore. I also have business interests overlooking the harbour, so on a daily basis I am again confronted with the outstanding views that lie before me.

With the wonderful scenery in both good and bad weather, this is an area that keeps drawing me back.

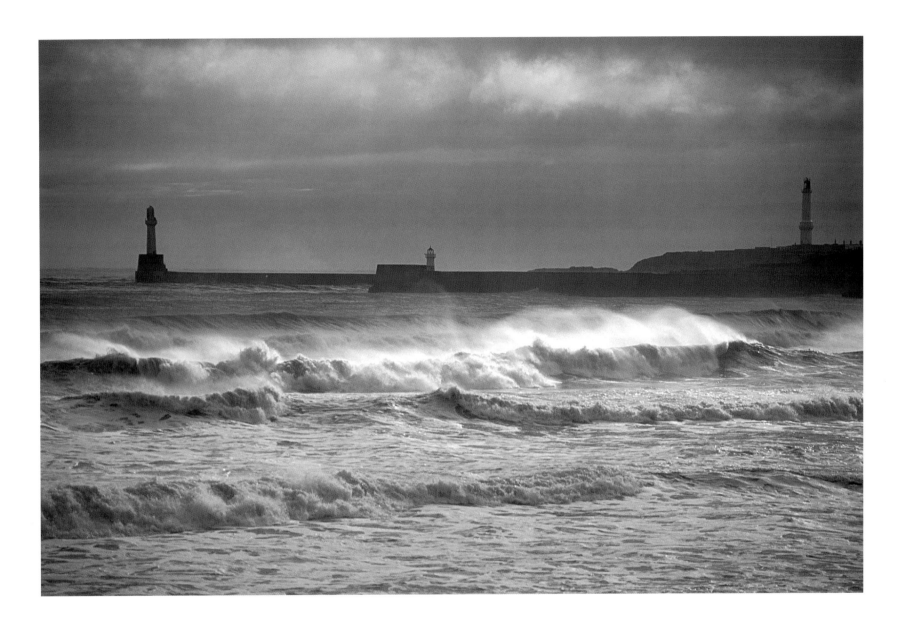

Stonehouse Farm, Airth, Stirlingshire

The favourite place of Dr Tom Sutherland

Though I did not recognise it at the time, growing up on Stonehouse Farm, right on the banks of the River Forth, was idyllic.

To the east, across the River Forth, lay the Ochil Hills, and during the holidays from Grangemouth High School it was my summer duty to be up around 4.30 am and well on my way by five to the banks of the river to round up the cows for the morning milking.

I clearly recall stopping by the gate of the pasture, putting one foot on the lowest bar and singing in full stentorian voice 'Oh What a Beautiful Morning', one of my very favourite songs from the musical *Oklahoma*. And looking across the Forth, as does this photo, there lay the Ochils.

It was not till I had been some years in the US and had seen at first hand both Oklahoma and the even more scenic Colorado where I now live, that I returned to the native heath and, more mature now, appreciated the true beauty of the Scottish scene.

Driving across the Kincardine Bridge, I took a trip along the foothills of the Ochils by Alloa and Dollar, thence to Stirling. The hills are even more spectacular up close, but my favourite view was still from that five-barred gate, looking into the rising sun, and appreciating the coming challenge of a new day.

In this photograph, the bales of straw illustrate the marvellous fertility of the soil on Stonehouse Farm. The pasture from which I brought in the cows in the early morning is now sown to grain, the dairy herd is no more, and I see the Ochils on my visits home today as in this scene. But the memories flow into each other of that glorious view, and will live in my head till my dying day.

Tom Sutherland

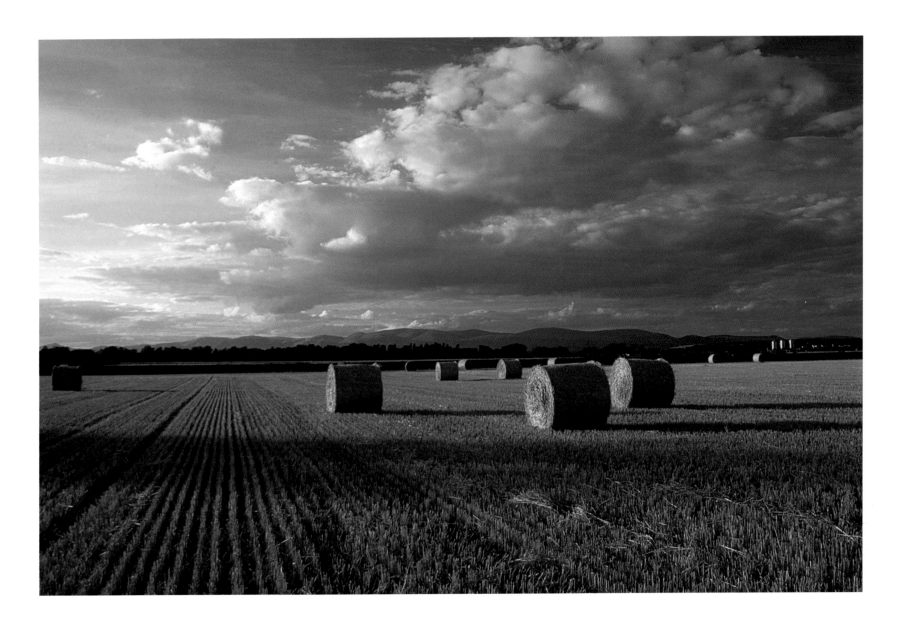

Port Grullain Bay, Isle of Iona
The favourite place of Kevin McKidd

When I was in my last year of primary school our class did a project on the island of Iona, culminating in a week-long school trip to the island. Being from Elgin in Moray, I had never been any further than Aberdeen or Inverness in my life.

This huge adventure to Iona had (and still has) a profound effect on me, never having been to the west coast. My childish eyes were struck by the beauty of it all. It seemed at once exotic compared to the rolling arable land of Moray, and strangely spiritual. Rambling around the bays and coves of the island, we were blessed with warm sunshine and endless days.

This particular spot on the west coast of the island became a favourite of mine. I remember picnicking on the grassy ledges of the ridge you see and falling asleep there to the sound of sea and gulls as a gentle summer breeze kept us cool. I vowed then that when I was a grown-up, I would return to this place.

Almost twenty years on I am (supposedly) now a grown-up and have returned to Iona many times. I have hitched there as a student and introduced its quiet charms to good friends over the years, all of whom seem to agree that it has a special quality that is hard to describe. I have camped (illegally) on the elevated machair to the right as you look at the photograph.

I took my wife to the island when she was eight months pregnant, as I suddenly had the urge to show her this place before we became parents. We walked around the north of the island, which is boggy and hard going at the best of times, let alone when carrying a small person inside you, but as we came over the ridge to see the Bay at the Back of the Ocean, she realised why we had come. We again picnicked on the grass, then fell asleep in the afternoon sunshine, the three of us.

Andy's photograph captures for me these happy endless summer days and makes me feel homesick for Scotland, but especially Iona. I am honoured to be part of this book and hopefully it will make a few others make the extra effort to reach this beautiful, remote spot. Thank you, Andy.

My next trip will be when my two children see this place. I can't wait and I hope they see as much in this small island as I do. They are called Joseph and Iona.

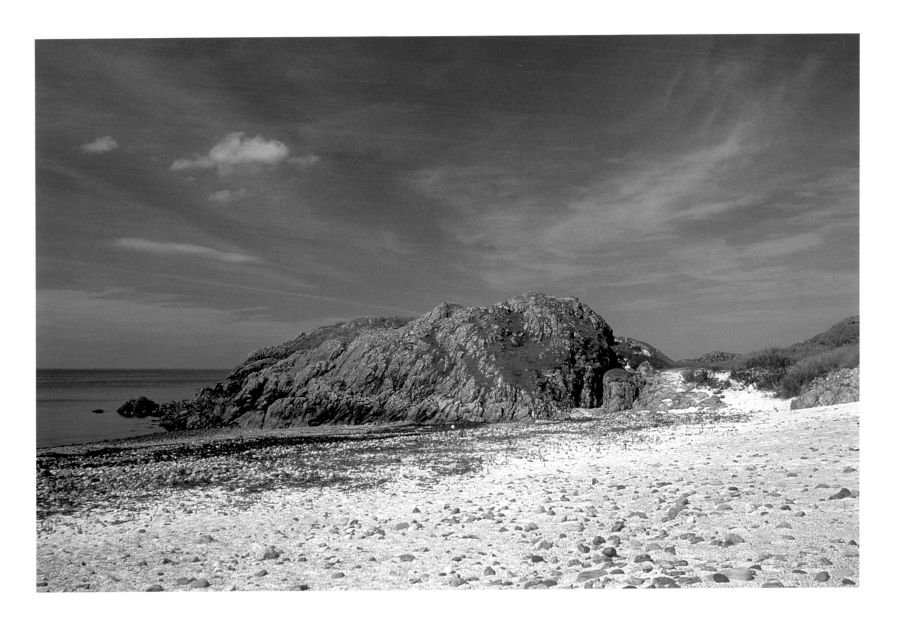

The Old Course, St Andrews

The favourite place of Hugh Dallas

Where else in the world could you capture so much drama, joy, disappointment, belief, disbelief, and then, within a few hours, enjoy the freedom to stroll and enjoy public access to one of the most famous sporting arenas in the world?

St Andrews, as everyone knows, is the home of golf, and the spectacle of the sport's most coveted prize being decided on that final day on that famous final hole is memorable, to say the least, for everyone.

I vividly remember Jack Nicklaus's famous victory in 1978, Seve Ballesteros punching the air in 1984 as he sank his final putt, a victorious Nick Faldo in 1990, and who will forget Constantino Rocca's 65-foot putt in 1995 to force a play-off with John Daly and, of course, Tiger Woods winning in 2000 with ease.

Last, but by no means least, was Arnold Palmer playing up the 18th for his last time ever and stopping to be pictured on this famous bridge over the Swilken Burn.

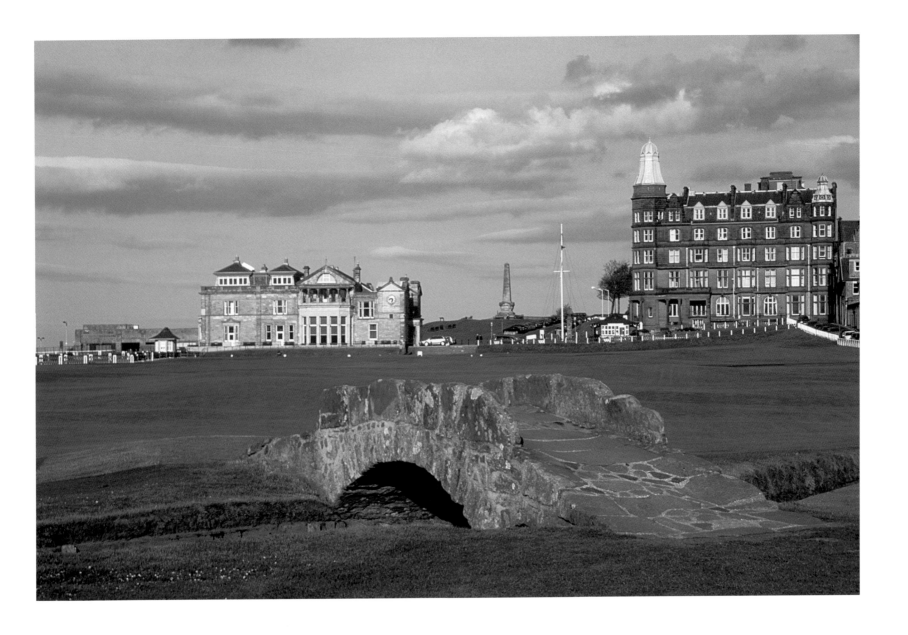

Callanish Stones, Isle of Lewis

The favourite place of Kenneth McKellar

This great stone circle on the Isle of Lewis was known to Herodotus as 'The Great Winged Temple of the Northern Isles'.

Erected almost 5000 years ago by pre-Celtic people of Iberian stock and dedicated to sun-worship, they are aligned north and south towards the Pole Star. They have watched the Stone Age merge into the Age of Bronze and they mark the dead of both.

Many years ago when I stood within the Callanish Circle for the first time, I felt a trembling, a thrill throughout my being, and this reappears with each visit. Standing there on the geology of twenty million years, one is forcibly faced once again with one's insignificance.

Callanish has had a great influence on my life—a house named 'Callanish' in Argyll, a house named 'Callanish' by my daughter in Australia, and lately a granddaughter named 'Callan'.

What more can I say?

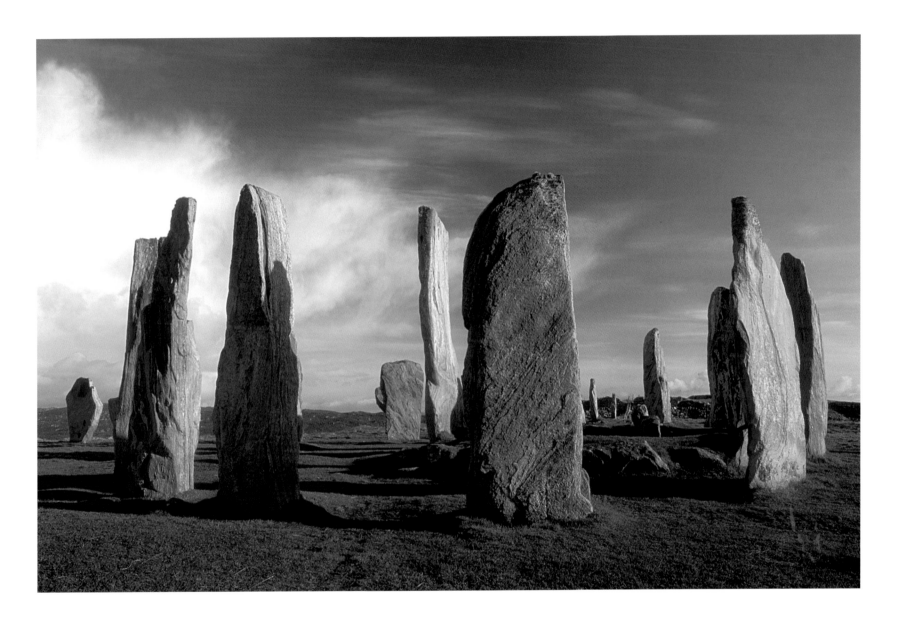

The Clyde above Hyndford Bridge, near Lanark

The favourite place of James Cosmo

I visited the Clyde at Hyndeford Bridge many times between the ages of 18 and 23: in the summer to fish the runs for the brownies, and in the winter to hunt the lady of the stream, the greyling. The peace to be found there was in such contrast to my home in Clydebank and John Brown's and Arnott Young's where I once worked. But that river, teeming with wildlife, was a refreshment for the soul.

I have fished in many parts of the world—New Zealand for giant rainbows, Mexico for marlin—but if I had just one day to spend on the river it would be as it was in my youth—a fly rod on the Clyde.

Many times I have thought to return, but to return to a place that once brought happiness and contentment is a dangerous thing to do. So that place will remain unsullied and pure in my dreams.

James Cosmo

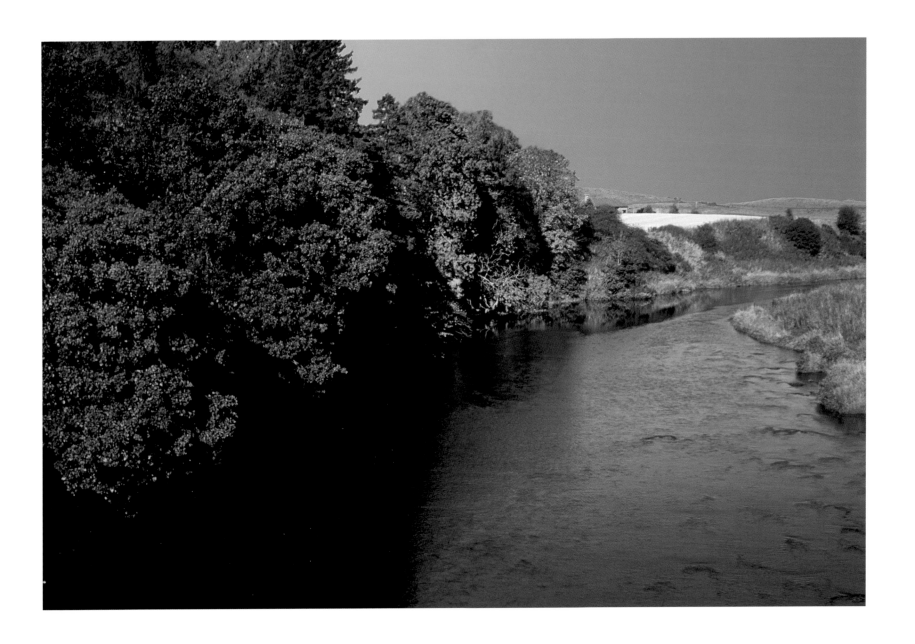

New Deer Parish Church, Aberdeenshire

The favourite place of Steve Forbes

This photograph evokes the moral compass that guided my grandfather, B C Forbes, who was born and raised in New Deer. He recognised what today too many don't: there is a moral foundation to business; to succeed, you must meet the needs and wants of others. To fulfill your ambitions and aspirations in a democratic free-enterprise society, you also serve others. In serving only yourself, he believed, you corrode your own soul.

In the first issue of *Forbes*, which he founded in 1917, thirteen years after he immigrated to America, B C Forbes wrote, 'Business was originated to produce happiness, not to pile up millions.'

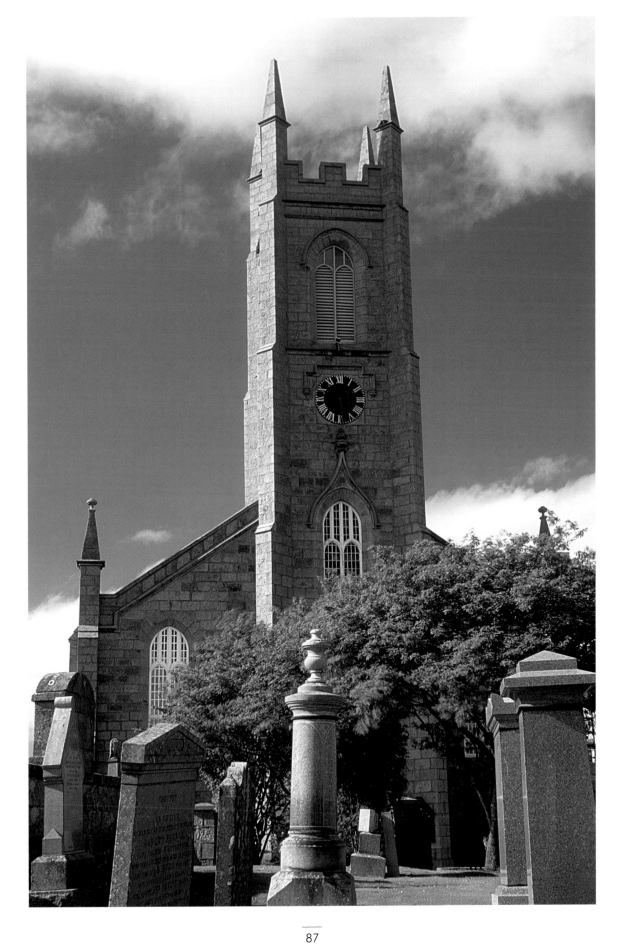

Lochgoilhead, Cowal
The favourite place of Tony Roper

The first time I set eyes on this entrancing natural wickerwork of mossy banks, golden trees and sun-dappled rocks that leads to the cave of Rob Roy in Lochgoilhead, Argyll, I thought for a twinkling that I had passed through some mystical fairy portal and found myself in the enchanted forest that Shakespeare described in *A Midsummer Night's Dream*.

I fully expected Oberon, Titania and Puck to appear from the myriad of colours that assailed my eyes. I could hear their voices in the rustle of a million russet-stained autumn leaves and their laughter tinkling in the sound of the lucid liquid that rushed from a hundred tiny waterfalls. This surely is where fairies live, I concluded.

Then I remembered that I was a product of the no-nonsense Glaswegian culture that laughed at such things. On the other hand…

The image captured here sets the scene perfectly for me until I can return and surround myself with the sounds and smells of this perfect piece of Scotland.

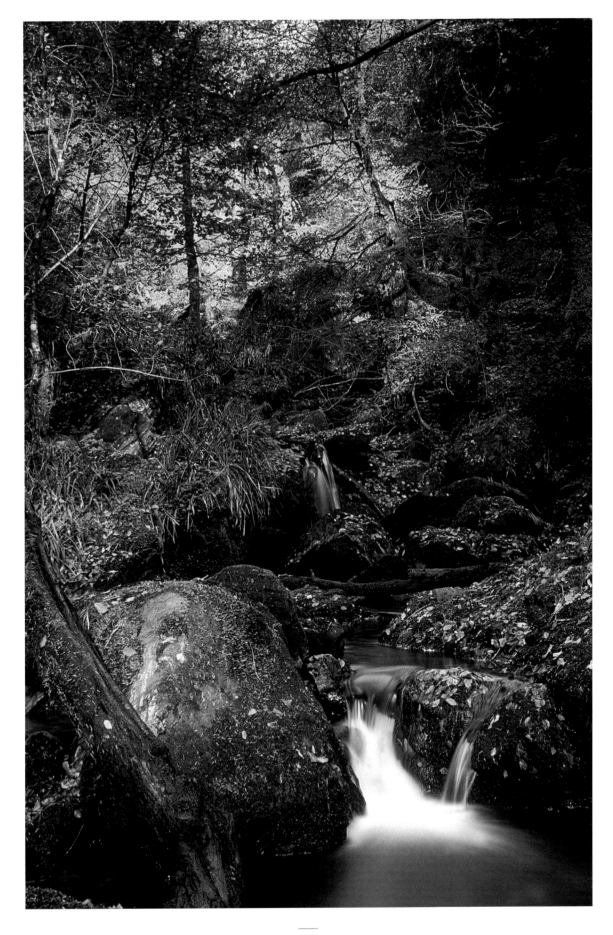

The 17th Green at Loch Lomond Golf Club
The favourite place of Dougie Donnelly

Just half an hour's drive from central Glasgow, Loch Lomond has always held a special place in the affections of my fellow Glaswegians. I fondly remember day trips with my family as a youngster with picnics on the shores of the loch, but now I am most often in this beautiful place to play one of the world's greatest golf courses.

I remember interviewing the course designer, Tom Weiskopf, when the course first opened, and complimenting him on a superb job of integrating a golf course into such a glorious setting. He immediately insisted that his job had been easy, that he had never seen such a stunning piece of land.

The view across the loch from the 17th green lifts my spirits every time I see it. I think the combination of loch, trees, the distant hills, Rossdhu House and the old castle is simply breathtaking, especially on such a beautiful day as this when the blue sky and slightly threatening cloud formation just add to the beauty of the view.

And if you can walk off with a par 3, so much the better!

Dougie Donnelly

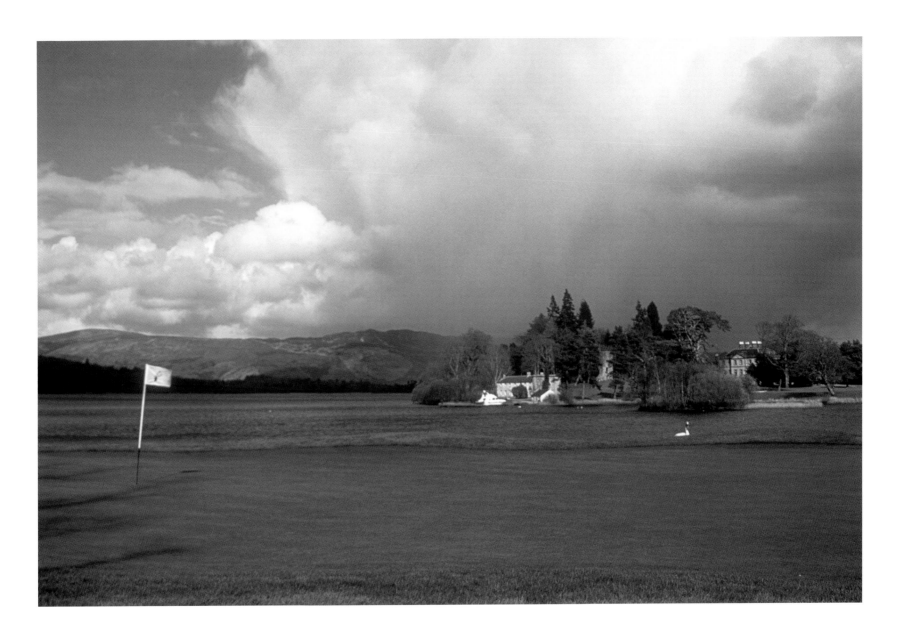

Portnahaven, Isle of Islay

The favourite place of Angus Roxburgh

When Andy asked me to name the part of Scotland that meant most to me, it was a toss-up between the red-earthed Mearns of my youth, where I went to school with him (I have some of his beautiful photographs of the area on the wall of my office in Brussels), and the place I have returned to at least twice a year for the past quarter-century—the Isle of Islay.

Islay won. It was my wife's family that originally came from there, and it's there that I return to in my mind when I am in far-flung places, for it is the perfect antidote to the turmoil and change that a news reporter deals with every day.

What I love about Islay is its ancient, unchanging landscape. And Andy has captured that brilliantly in this unusual view of my adopted village, Portnahaven. Look at those primeval rocks in the foreground, bulging out of the sea like hippopotamus hide, rubbed smooth by thousands of years of pounding tides and storms.

The fishermen's cottages are only a hundred or so years old, but that's also quintessential Islay—a ribbon of white against blue sky. Usually my view from 'home' is from one of these houses, looking out across the rocks to the Atlantic Ocean. Maybe it's that contrast that makes Islay special: the peaceful, ancient land, anchored in a restless ocean.

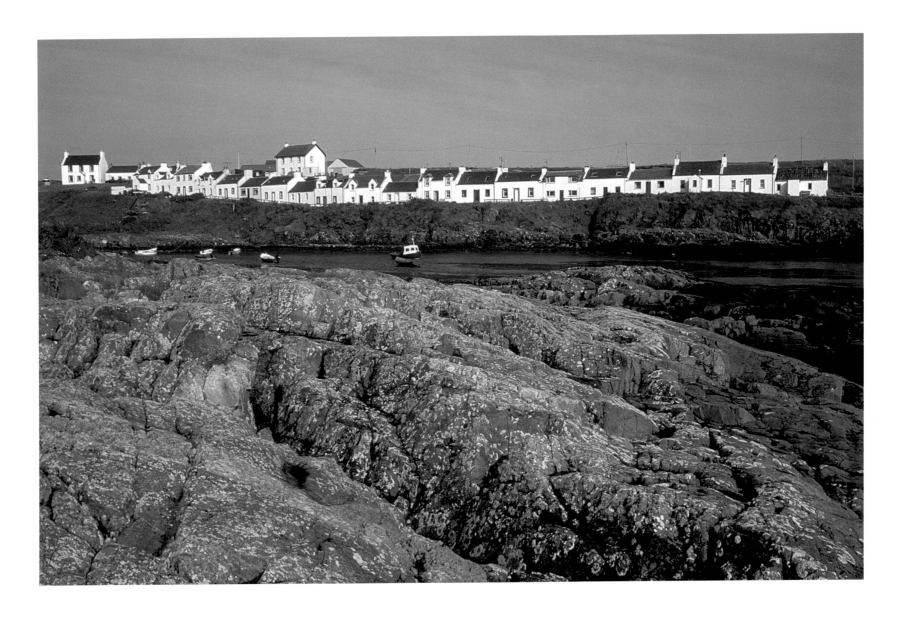

Dunure Castle, Ayrshire

The favourite place of Lorraine McIntosh

As a child growing up in the heart of Ayrshire, I will never forget the first time I saw the beach at Dunure. There are other more spectacular beaches in Scotland, but when I saw this one I claimed it as my own. I couldn't believe that this was in fact Ayrshire—no pits or factories, just rocks and shore.

If you are lucky enough to catch the place on a winter's day with the sun peeking through the clouds, as in this picture, maybe you will understand the beauty of the place.

I return to it time and time again, now with my children, and, who knows, maybe one day they will return with theirs!

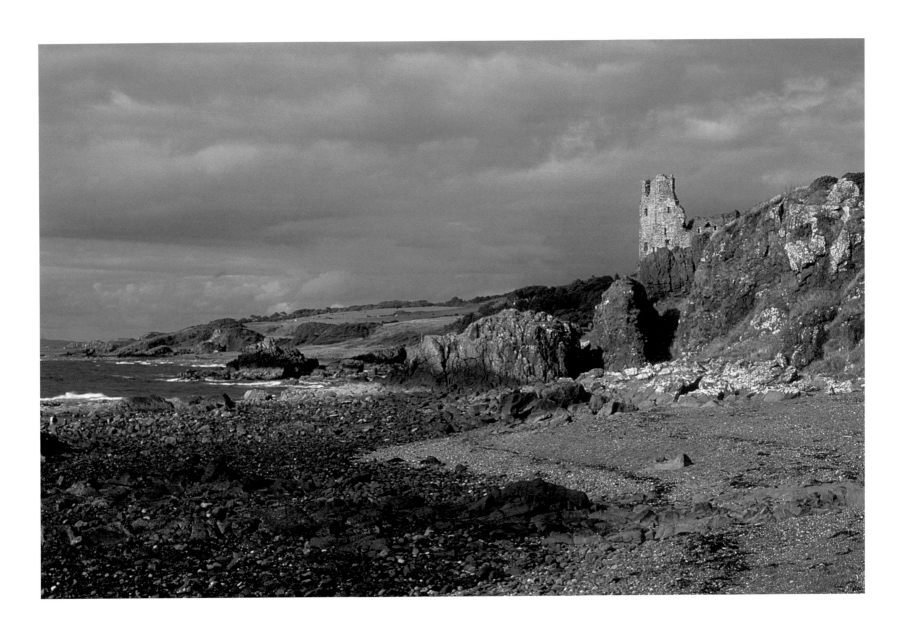

Braid Hills, Edinburgh

The favourite place of John Greig

My abiding memory of Braid Hills Golf Course is of regular Sunday morning walks with my son Murray as a little boy, a friend of mine and his dog. Even though these walks were thirty years ago, I can still see Murray, full of energy, running ahead of us all.

I have also played golf at Braid Hills several times and on each occasion I have been captivated by the view over Edinburgh. With the Fife coast beyond the Firth of Forth, the unmistakable shape of Edinburgh Castle, and, to the right of where Andy took the picture, Arthur's Seat, then on towards Cockenzie and the East Lothian coastline, I still hold a place in my heart for this view.

As a player with Rangers, I was expected to keep fit in my own time as well as training with the club, particularly in the close season. I took part in many solitary training runs over the Braid Hills countryside at that time.

I have lived in Glasgow for twenty-six years but I still retain a real affection for the beautiful city of Edinburgh, the place of my birth, and the wonderful views from the Braid Hills.

John Greig

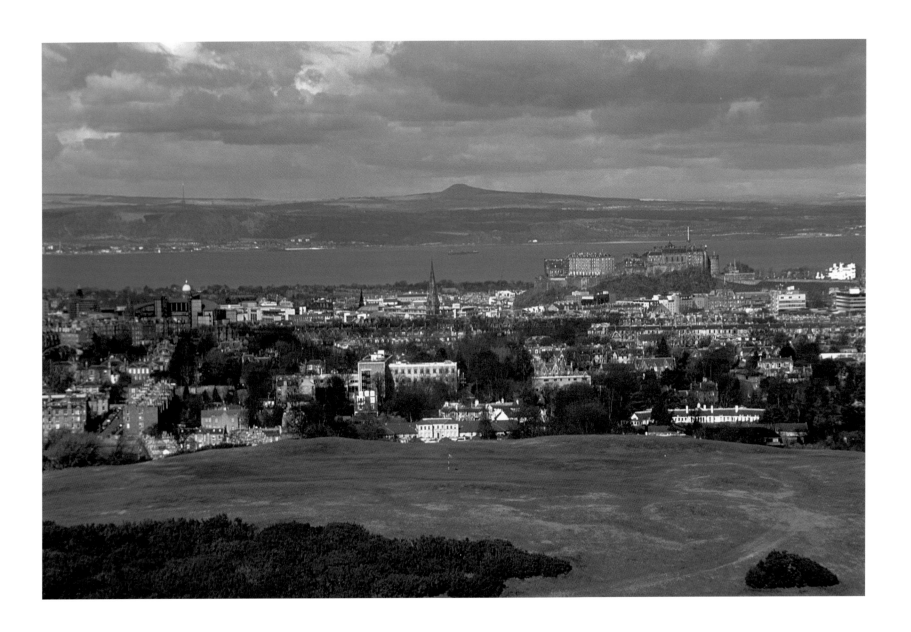

Cruden Bay Golf Course, Aberdeenshire

The favourite place of Fiona Kennedy

There are few places in the world where I look out of the window and feel 'I'm home'. The view from our chalet at Cruden Bay makes me feel exactly like that, despite the fact that I'm a west coast girl!

I look down on what appears to be a green lunar landscape, all dewy and mysterious in the early morning, the light often most stunning at 5 am. No one about, just the distant movement of the North Sea beyond the sand dunes, an occasional ship sailing by to the Orkneys or Shetland Islands. Peace!

Although you can't see it in Andy's wonderful shot, to the left are the haunting and spectacular ruins of Slains Castle which attract Bram Stoker fans from all over the world.

This natural golf links course is amongst the finest in the world and keen golfers beat a path to this place where my husband and children love to play. They just walk down to the first tee and off they go, hail, rain or shine!

Often I stand at the kitchen window preparing a meal and get carried away with this spectacular vista. I watch golfers come and go and think how lucky I am.

Fiona Kennedy

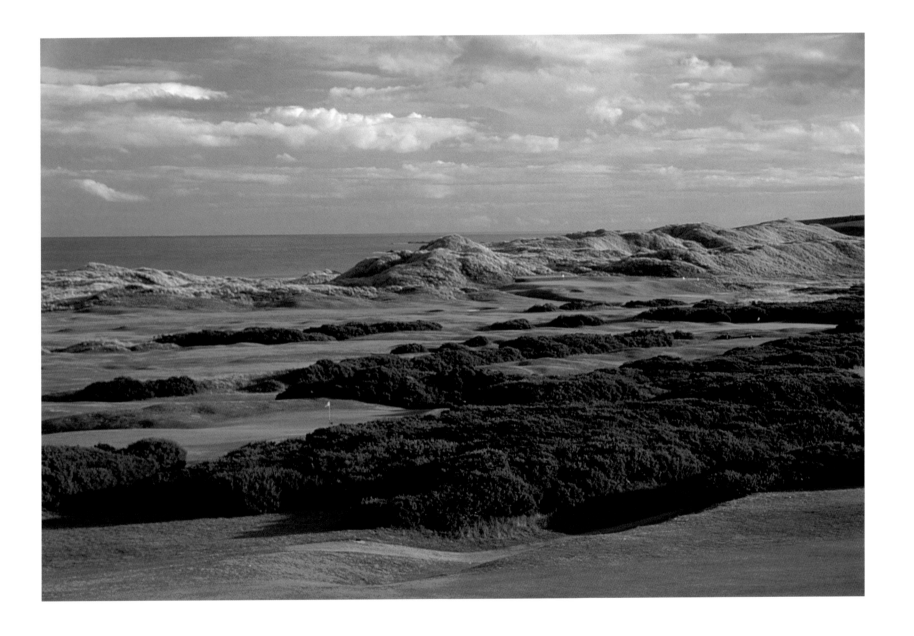

Ettrick Bay, Isle of Bute

The favourite place of Tam Cowan

The more I look at this picture the more I think Andy Hall must have indulged in a little bit of trick photography. Clouds at Ettrick Bay? No way. The Ettrick Bay I so fondly remember boasted non-stop blue skies, crystal-clear water and the most incredible sandy shore that meant you could walk halfway to Ireland without getting your knees wet.

I first enjoyed this view as a three-year-old when my dad went on a 25th-anniversary camping trip to Rothesay with the 17th Motherwell BB Company and I tagged along. Well, it was either that or go to Disney World with my mum and wee sister... Aye, right!

Ever since that unforgettable moment (the Glasgow Fair of 1972), the Isle of Bute—and particularly Ettrick Bay—has had a special place in my heart, and this photo triggers so many special memories. The taste of the Currie's Red Kola they sold from one of the tents. The joy of finding a freshwater spring on the beach. And, of course, the tearoom at the far end of the bay (still there to this day) that sold the most fabulous cream cakes.

I still return to Ettrick Bay at least once a year and the sights, the sounds and the smells are always exactly the same. Only one thing has changed over the years... where did that little boat suddenly appear from?

Guess I'll just have to keep going back until I find out...

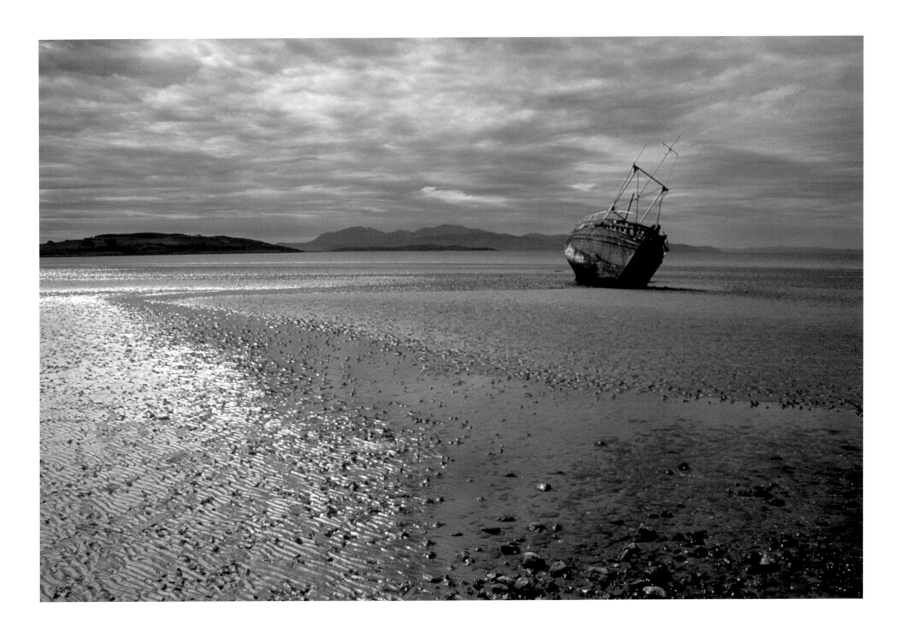

The Kyles of Bute, Cowal

The favourite place of Michelle Mone

This photograph of the Kyles of Bute perfectly encapsulates the beauty and tranquillity of Scotland. We may complain about receiving more than our share of rainfall but this is one of the reasons that we have such spectacular scenery.

While standing at the viewpoint looking down the Kyles of Bute it is easy to forget the hustle, bustle and stress of work and city living. A landscape such as this has not been altered by time or technology. Its beauty is breathtaking and will always hold a special place in my heart.

Michelle & Mone

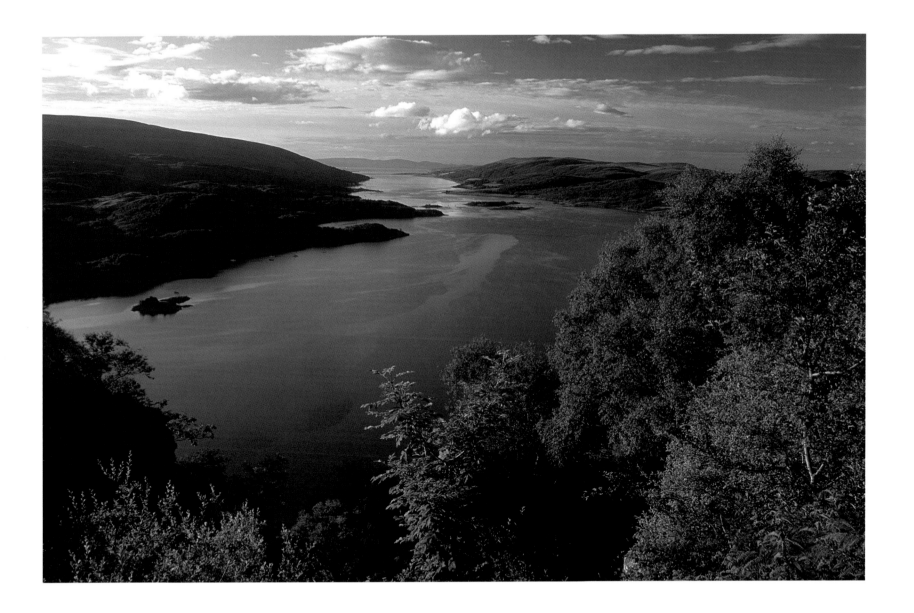

Hawick, the Borders
The favourite place of Sir Chay Blyth

There are two 'happenings' in Hawick that involve almost everyone born there from a very early age. One is rugby and the other is the Common Riding. The latter dates from the time of the Battle of Flodden, fought between the English and the Scots in 1513. The Scots came second! However they were not to be completely outdone.

In 1514 the English, on their way back home, camped at Hornshole just outside Hawick. It took a long time in those days to move armies, what with the pillaging, raping and not to mention the drinking that went on. Whilst the English were camping at Hornshole, a group of Callants from around the Border Towns gathered together and charged through the English lines. They probably didn't do much harm but the English banner (flag) was captured by a Hawick Callant who rode like fury with it back to Hawick.

The Battle of Flodden and the capturing of the banner has become a re-enactment through the Hawick Common Riding ceremonies, the ancient custom of riding round the boundaries of the common land. This was to make sure no one encroached on the land and people didn't forget where the boundaries were.

The Common Riding takes place every year and up to four hundred riders ride to the boundaries at any one time. A Cornet (a young unmarried man), who is elected by his peers each year, leads the riders. The ride-outs, as they are called, take place over a six-week period during May and June; they are always on a Tuesday and Saturday. The main ride-out consists of a 24-mile ride, and at the half point the riders and horses rest for two hours. Family and friends join them for the break and consume lots of alcohol, just like they would have done in 1514!

These rides are magnificent, with great camaraderie, and the countryside is so beautiful. The routes are allowed through the generosity of the local farmers and landowners.

Felicity, my wife and I, stay at a great holiday complex called Headshaw Farm (near Ashkirk, about five miles outside Hawick) with our horses. We have holiday accommodation and stabling for the horses, but much more than that, thanks to the owners Nancy and Gordon Hunter, we can ride over their land and onto the Buccleuch Rides, again made possible by the landowner, the Duke of Buccleuch.

The scenery is stunning, and seen from the back of a horse it is, for me, one of life's great pleasures. We go on these hacks in between the ride-outs just to keep the horses fit and to enjoy what is one of the very best experiences in life.

The River Endrick, Fintry, Stirlingshire

The favourite place of Annie Ross

Many years ago, when I was living in London and not at the pinnacle of my health, my dear brother Jim came to see me. 'I'm taking you up to Scotland to get re-energised,' he said. 'It's a place called Fintry, you'll love it.' I had never heard of Fintry but I got to know it well.

Jim had rented a small estate that consisted of a house, a grass tennis court (somewhat run-down), a vegetable garden and a small burn where you could fish for trout. There were many various colours of rhododendrons, a bluebell dell and a small waterfall.

At the end of the day, I would watch as the local doctor pulled up in his car to the river bank. He would go to the boot and take out his fishing rod, walk slowly down to the Endrick and cast. He was a remarkable man, very gentle, and he had been in a Japanese prisoner of war camp. He had seen and endured many things.

With the sunset casting a pink glow in the sky, the air so clear, it gave me a feeling of complete peace.

I will always have a warm place in my heart for Fintry.

Annie Ross

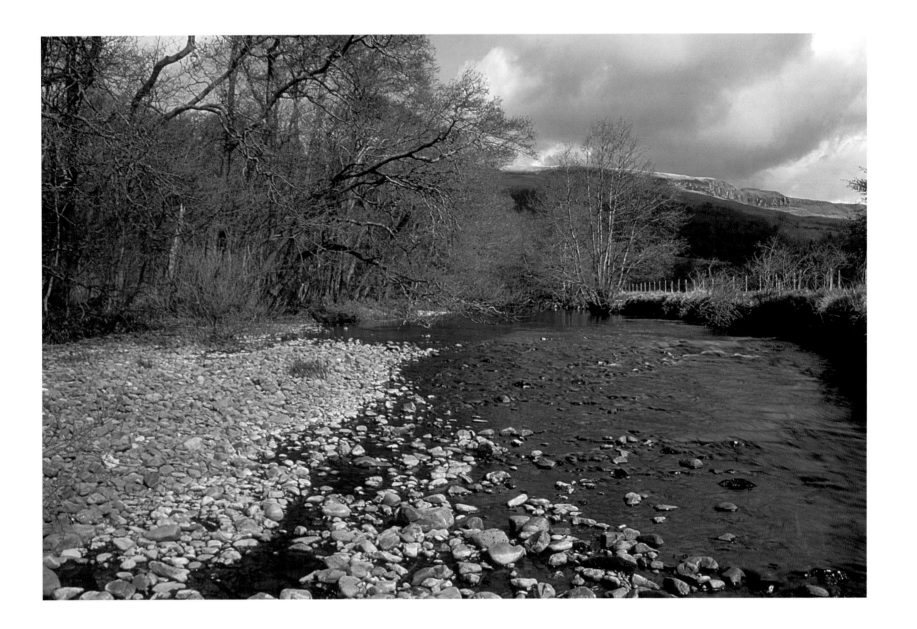

Eyemouth Harbour, Berwickshire

The favourite place of John Bellany

Eyemouth for me is one of the most beautiful places in the whole world. Beauty is a difficult word to define, but Eyemouth *is* beautiful.

The harbour which runs through the town is the hive of activity it always was, especially when all the boats come in from the fishing. The sights and sounds of the harbour area fill my heart with such rich memories of my past and the past in general. The history of the area, from the Eyemouth disaster and further back to the time of *The Bride of Lammermoor*, combined with the sheer stoicism of its people, fills me with an enormous sense of the continuum of life, with all its rich tapestry.

I have painted this home territory so often, sometimes drawing on childhood memories, sometimes on observation. Some of the allegories are from my fertile imagination, especially those of the Eyemouth disaster, which happened in the year my grandfather was born.

Eyemouth gives me a perpetual sense of wonder.

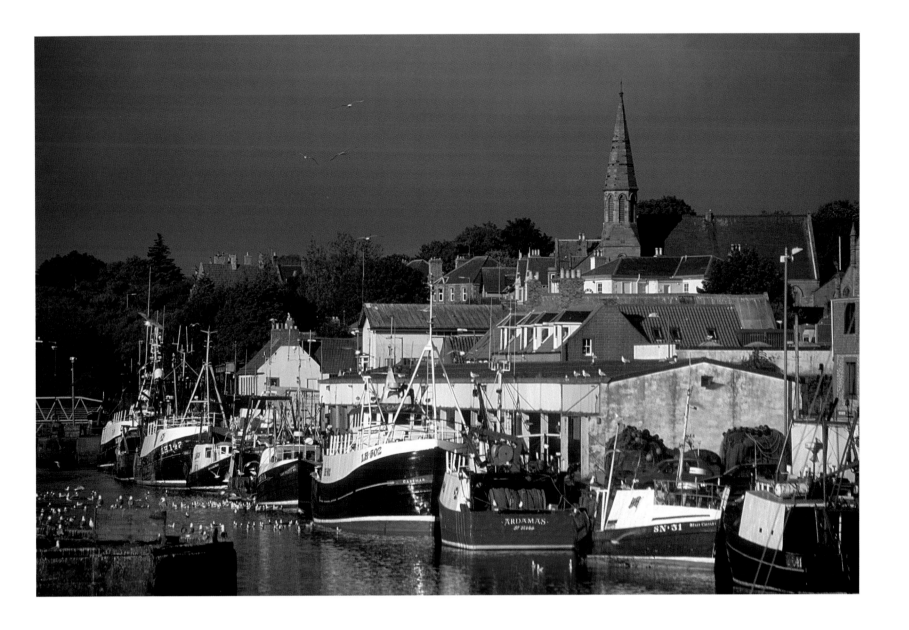

Gairloch, Wester Ross
The favourite place of Gavin Esler

Gairloch is the Scotland of my childhood, the country where the air is so clean it intoxicates you, the sea so clear you can see the sea urchins beneath the oars of your boat.

It is a country where the summer evenings never end. They go from the gold tones of the setting sun kissing the sea, in this photograph, to the purple of the gloaming.

I would stand at the very spot in Andy's photograph, feeling the cold seawater and sand between my toes, staring south to the mountains. I would dream of catching salmon (I never did) but have to settle for small trout and eels which flicked themselves into knots around my line.

I always knew, even as a small boy, that I would leave Scotland and travel the world. I always knew I would, in one sense, never leave completely. I am still there in Gairloch, still trying to get a salmon out of the burn, still watching the seals near the old lighthouse to the north, still sleeping in a tent among the sand dunes, supping the air like a fine malt, enjoying the best sleep of my life.

Home. Belonging. Scotland. A place of the heart.

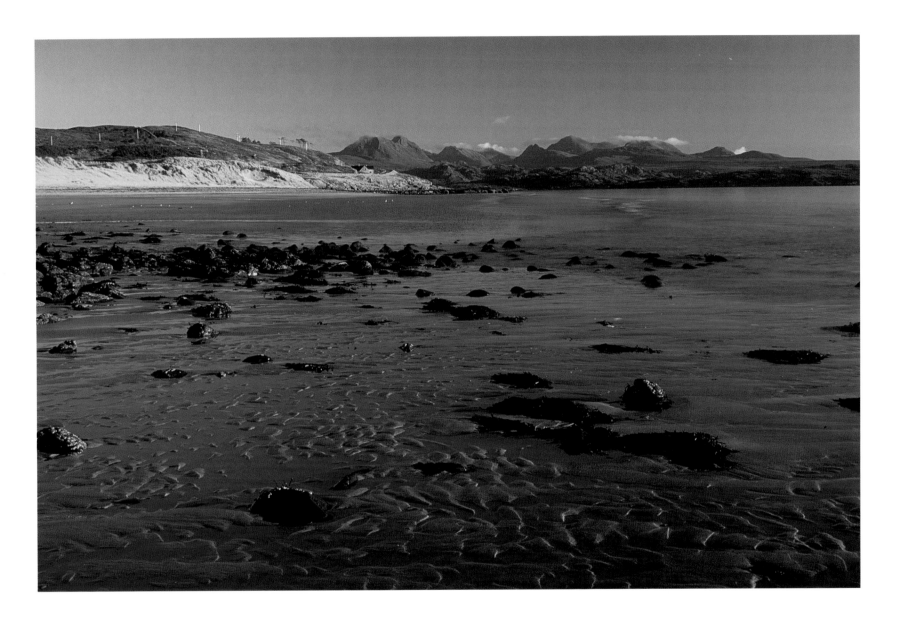

Biographies in Brief

Born in Port Seton in 1942, **John Bellany** trained at Edinburgh College of Art and the Royal College of Art, London. He has received numerous awards and has exhibited in Boston, Dublin, New York and Warsaw. His was the first one-man show to be held at the National Portrait Gallery in London in 1986. He was elected a member of the Royal Academy in 1991.

☆

Jackie Bird is one of the best-known faces in television in Scotland. She presents BBC Scotland's flagship nightly news programme *Reporting Scotland* as well as being host of other yearly BBC Scotland programmes such as the *Hogmanay Show* and *BBC Children In Need*.

☆

Dame Elizabeth Blackadder is one of Britain's most respected contemporary artists, producing floral, still-life and landscape paintings. She was the first woman elected to both the Royal Scottish Academy (1972) and the Royal Academy of Arts (1976).

☆

As an international yachtsman, **Sir Chay Blyth** has had a distinguished and adventure-filled life. In 1971, aboard the 59ft ketch *British Steel*, he became the first person to sail non-stop around the world against the prevailing winds and currents. Through his company Challenge Business, he encourages others to sample the adventurous life.

☆

Ken Bruce is one of Radio 2's stable of extremely popular presenters. His easy style attracts a huge listening audience every weekday.

☆

As well as being Director of Nations and Regions for Channel 4, with overall responsibility for the channel's strategy outside London, **Stuart Cosgrove** presents the extremely popular *Off The Ball* for Radio Scotland with Tam Cowan.

☆

James Cosmo is one of Scotland's most respected actors and producers. He has played significant roles in such diverse films as *Braveheart* and *Trainspotting*, as well as in the successful television series *Roughnecks* about the oil industry.

☆

Alongside Stuart Cosgrove, **Tam Cowan** presents the award-winning radio show *Off the Ball* on Radio Scotland on Saturday afternoons, as well as the irreverent and highly popular series *Offside* for BBC Scotland, reflecting on the vagaries of Scottish football. He also has his own regular newspaper column.

☆

As a producer, composer and performer of traditional and contemporary Celtic music, **Phil Cunningham** is one of Scotland's most respected and entertaining musicians.

☆

Recently retired, **Hugh Dallas** is Scotland's most respected international football referee. He has officiated in World Cups as well as European Championships, European club competitions and some of the most high-profile Scottish domestic matches of the past fifteen years.

☆

As an artist himself and promoter of artists, **Richard Demarco** has played an important part in shaping the art world in Scotland in the twentieth century. He continues to encourage and inspire artists and photographers, including myself, with his unbridled and visionary enthusiasm.

☆

Based in Fife, **Isla Dewar** has written many successful novels, including the best-selling *Women Talking Dirty* which was made into a film starring Gina McKee and Helena Bonham Carter.

☆

Dougie Donnelly is one of the BBC's top television sports presenters with more than twenty years experience of live broadcasting from the country's major sporting occasions. He has recently been appointed as the Chairman of the Scottish Institute of Sport.

☆

Gavin Esler joined the BBC *Newsnight* presenting team in January 2003. He has anchored BBC News 24 since 1997 and reported for news and documentary programmes across Europe, Russia, China and North and South America.

☆

Dr Winnie Ewing is President of the Scottish National Party. Her political life has been eventful and distinguished, earning respect from all parties in the UK and Europe, where she became known as Madame Écosse.

☆

Steve Forbes is a grandson of pioneering publisher Bertie Forbes, founder of the influential *Forbes* magazine. Based in New York and with Steve as President, *Forbes* is regarded as the leading business publication in its field, attracting a huge readership in the USA, Asia and Europe.

☆

Following an illustrious career as captain of Glasgow Rangers and Scotland, **John Greig** was voted Rangers' greatest ever player. He is now a director at Ibrox.

☆

After an outstanding career as captain of Liverpool FC, **Alan Hansen** has gone on to a highly successful media career as a football analyst with the BBC and presenter of excellent football documentaries.

☆

Sarah Heaney is a presenter on Scottish Television's *Scotland Today* and also presents *Movie Juice*, STV's film review programme.

☆

An entrepreneur and philanthropist, **Sir Tom Hunter**'s success in the world of business has benefited, through his generous donations, many aspects of Scottish life, particularly education.

☆

Based in the United States, **Alastair Johnston** is President of IMG International as well as being a director of Glasgow Rangers Football Club.

☆

Jimmy Johnstone is Celtic's greatest ever footballer. Throughout his career, he tormented defences all over the world, at the same time gaining the respect, admiration and affection of teammates and opponents alike. His proudest moment was winning the European Cup against Inter Milan in Lisbon in 1967.

☆

Born in Lewis in the Outer Hebrides, **Calum Kennedy** won the National Mod Gold Medal in 1955. Since then he has travelled the world performing in concerts and on television, captivating audiences with his wonderful singing voice.

☆

Daughter of Calum, **Fiona Kennedy** shares his beautiful singing voice in her treatment of both traditional and contemporary songs. She combines recording and performing with a career as a presenter and director of Tartan TV, which is enjoying a growing audience at home and in the USA.

☆

In 2004, **Denis Law** was voted Scotland's greatest ever footballer, having starred for Manchester United and Scotland in the sixties and seventies.

☆

Recently retired from rugby union, **Kenny Logan** has had a distinguished career in club and international rugby, having played for Stirling County, London Wasps, Glasgow and the Barbarians. Kenny has 70 international caps for Scotland.

☆

Also known as Jolomo, **John Lowrie Morrison** is one of Scotland's most successful landscape painters,

specialising in vibrant and evocative representations of Scotland's west coast. He has a studio in Tayvallich.

☆

Originally from North Uist, **Calum Macdonald** is a founder member of the internationally acclaimed band Runrig. As well as being a percussionist, Calum's songwriting with his brother Rory conveys the essence of contemporary Gaelic culture.

☆

Best known for his character of Archie in *Monarch of the Glen*, the extremely popular BBC series set near Newtonmore, **Alastair Mackenzie** has played many contrasting television roles in a wide variety of genres.

☆

Karen Matheson is often regarded as having the most beautiful traditional singing voice in Scotland today. As well as having a successful solo career, she is the principal voice of Capercaillie.

☆

Alexander McCall Smith is one of Scotland's most prolific and successful novelists of recent times, particularly with his series based on the adventures of Precious Ramotswe, Botswana's only female private detective.

☆

Hugh McIlvanney is widely regarded as the outstanding sports writer of his generation. He is the only sports specialist to have been voted Journalist of the Year. In 1996, he was awarded the OBE, and in 2004, the Scottish Daily Newspaper Society presented Hugh with a lifetime achievement award.

☆

Lorraine McIntosh enjoyed a very successful musical career with Deacon Blue alongside husband Ricky Ross, before becoming a regular actress on BBC's popular series, *River City*.

☆

Kenneth McKellar is one of Scotland's best-loved singers. For fifty years he has entertained Scots at home and abroad with his classically trained voice. He is particularly well known for his distinctive recordings of the songs of Robert Burns.

☆

Kevin McKidd is one of Scotland's most versatile and respected actors both in the UK and, increasingly, abroad. His most recent starring role is in *Rome*, an epic saga set during the last years of Julius Caesar's reign.

☆

Voted as Aberdeen FC's greatest ever player, **Willie Miller** captained the Dons to their most famous triumph in Gothenburg in 1983, when he held aloft the European Cup-Winners' Cup after defeating the famous Real Madrid. He is now Director of Football at Pittodrie.

☆

As an entrepreneur with an innovative approach to marketing, **Michelle Mone** has gained remarkable success with her company Ultimo. From modest beginnings, she has created a company of international significance through hard work and determination.

☆

Colin Montgomerie is Scotland's most successful international golfer. He has consistently ranked amongst the world's best golfers since moving into the top 10 of the World Rankings in 1994.

☆

Marti Pellow is the lead singer of the recently reformed Wet, Wet, Wet, one of the most successful Scottish bands of the past twenty years.

☆

Colin Prior is an inspirational landscape photographer. Having produced beautiful books, calendars, prints and cards of Scotland's wilderness and wild places, he is now focusing his attention on the wild places of the world.

☆

Gerry Rafferty was a hugely successful musician at the end of the 1970s thanks, in part, to the still popular song 'Baker Street' and his solo album *City to City*, alongside memorable songs from his time with Stealer's Wheel. Gerry continues to write and record in his own distinctive style.

☆

Siobhan Redmond is one of Scotland's most established actresses, having had many successes on stage, on television and on radio including the highly successful series *Between the Lines* and *Holby City* as well as varied roles in *Sea of Souls* and the acclaimed *The Smoking Room*.

☆

Lord George Robertson of Port Ellen is one of the UK's most respected politicians. He is a former NATO Secretary-General, serving from 1999 to 2003. Previously, he was Britain's Defence Secretary from 1997 to 1999.

☆

As a writer and actor, **Tony Roper**'s career has been rich and varied. Perhaps his finest achievement, though, has been the enormous success of *The Steamie*, a fascinating and hugely entertaining insight into Glasgow's social history set in a communal laundry.

☆

Sister of Jimmy Logan, **Annie Ross** has spent most of her life in the United States pursuing a highly successful career as a jazz singer.

☆

Originally from Dundee, **Ricky Ross** has followed his hugely successful career with Deacon Blue by establishing himself as a thoughtful and respected songwriter and solo performer.

☆

As a journalist, writer and television reporter based in Brussels, **Angus Roxburgh** has been one of the leading commentators on European events in recent years, both as BBC's European correspondent and, more recently, as a freelance journalist.

☆

Dougray Scott is one of Scotland's most accomplished and versatile film, television and theatrical actors. His films include *Mission Impossible 2*, *Enigma*, *Ripley's Game* and *To Kill a King*.

☆

After beginning his working life in the shipyards, **Alan Sharp** has had a prolific and successful career as a screenwriter for film and television. His writing has received much acclaim, in particular his screenplay for *Rob Roy* in 1995. 2006 brings a new film based on several years in the life of Robert Burns, on which he is working with James Cosmo as producer.

☆

Dawn Steele is best known for her role as Lexie in the highly successful BBC series *Monarch of the Glen*, set in the Scottish Highlands, which she played for five years. Among other projects, she has starred in *Sea of Souls* with one of Scotland's most respected actors, Bill Paterson.

☆

Appointed manager of Celtic in 2005, **Gordon Strachan** has had an extremely successful playing career at club and international level. As well as being a Premiership manager with Southampton, he has enjoyed much success as a football analyst with the BBC before taking up his new role.

☆

An academic, originally from Airth, **Dr Tom Sutherland** moved to the United States early in his career. In 1985, two years after taking up a position of Dean of Faculty in the American University of Beirut in Lebanon, Tom was kidnapped by gunmen from the Islamic Jihad. He spent nearly six and a half years in captivity.

☆

Emma Thompson is one of Britain's most accomplished actresses and has received Oscars in 1992 for best actress in *Howard's End* and in 1995 for the best screenplay with *Sense and Sensibility*.

☆

Louise White is a presenter on STV's flagship news programme *Scotland Today*, having begun her career on Radio Scotland.

☆

Sir Ian Wood is Chairman and Chief Executive of the Wood Group, one of the leading companies in the global oil industry, based in Aberdeen.

The Last Word

By publishing the two volumes of *A Sense of Belonging to Scotland* I've achieved what I set out to do six years ago. It has been an extremely challenging and stimulating period for me, but it has also yielded many rewarding experiences.

On a personal level, I've met and, in many cases, become friends with people whom I've always admired and respected in their chosen fields. I've photographed places in Scotland, among them many hidden gems that I'd never otherwise have had the joy of visiting, let alone of trying to capture their essential elements in atmospheric light.

Ewan McGregor described the images in volume one as 'the most beautiful collection of photographs that I have ever seen.' This accolade from Ewan I have accepted as a challenge and a motivation to maintain and, where possible, to exceed the quality of photography in *Further Journeys*. I'm pleased with the attempt, but it is for others to decide where and when I have succeeded.

Photographically, I'm extremely proud of both volumes of *A Sense of Belonging to Scotland*. What started off as the germ of a simple but unique idea, too huge and difficult to contemplate, has become a reality. There have been many frustrations along the way, often when the non-appearance of anticipated weather conditions after hundreds of miles of driving meant having to return at a later date. But I honestly feel that the frustration has been a necessary part of the process. Over the years this rather negative feeling has been replaced by a much calmer feeling of patience and an overwhelming sense of privilege when all the elements, particularly light, come together in perfect harmony. It is like a note being struck in tune.

I've learned, or perhaps always knew but was less prepared to wait, that there is always sunshine after the rain, and if it is raining, then it will clear the atmosphere of impurities. It is rain that provides the organic landscape and when it clears or, more accurately, is in the process of clearing, there will be fabulous atmospheric conditions to photograph.

Of all the factors, light and its quality and direction is the key. It is the most elusive and tantalising of all the elements. The excitement that comes when it deigns to make itself available when I'm ready and waiting for it is unlike anything else I've experienced. It feels like a reward for months of planning, weeks of preparation, days of driving, hours of waiting and minutes, often only seconds, of photographing some of the most beautiful and diverse landscapes that Scotland can offer.

I'm a great one for 'distilling'. My goal as a landscape photographer is to distil in a single image the feelings of longing for and belonging to Scotland felt so deeply by all the participants in the book. If I were to distil my enthusiasm to a single element, it would be the indescribable feeling of elation when the shot that I have carried in my head—sometimes for up to two years—is finally committed to film in my camera.

However the photograph that captures my unquenchable enthusiasm for this unique project wasn't taken by me, but in a spontaneous moment by my close friend, Dougie Abernethy. Last April we were on the east coast of the beautiful Isle of Harris at about six in the evening, looking over the oldest rocks in the world, Lewisian gneiss, towards Scalpay for Elizabeth Blackadder. Elizabeth had written an inspirational letter of introduction to her favourite place, looking over the Golden Road.

This shot had eluded me on a previous trip to the Outer Hebrides and looked as if it might again, after two ferry journeys and over a thousand miles of travelling. The perfect light made itself available for less than a minute and when, after hours of waiting, it was consigned to film, the involuntary moment of elation was captured by Dougie, unknown to me.

Elizabeth's picture was one of the last photographs to be taken for this collection. After six years, my enthusiasm and passion for Scotland's landscape has never waned for a moment. Dougie's picture says it all.

Andy Hall
October, 2005